PAST & PRESENT

CONCORD

OPPOSITE: Oscar A. Blackwelder rides a stripped-down Mitchell automobile in front of the 1876 Cabarrus County Courthouse. This c. 1912 photograph shows the courthouse prior to a major remodel that changed the front porch and removed the iron fencing that surrounded the property. Two children stop to watch the automobile and pose for the picture. The 1876 courthouse is the most prominent historic structure in downtown Concord and houses Historic Cabarrus Association Inc. and the Cabarrus Arts Council. (Courtesy of Historic Cabarrus Association Inc.)

CONCORD

What she said → *Thank you so much for all you do for our historic city!*
☺

Michael Anderson and Ashley Sedlak-Propst

#HeyNow
M.A.

Ashley Sedlak-Propst

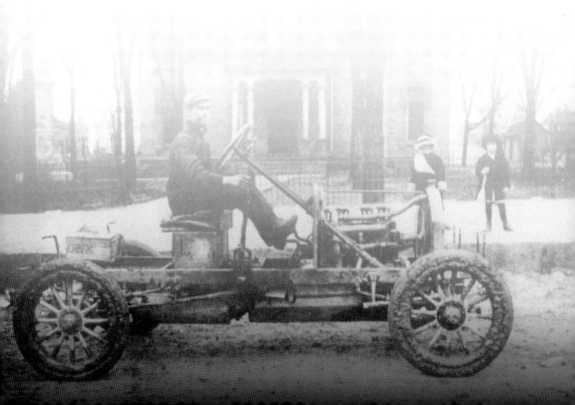

For my mom and dad, who always encourage me to follow my dreams and continue to support me in my various passions. I'm making history every day because of you. I love you both.

—*Ashley*

I'd like to dedicate this to my wife, Corrie, my kids Dylan and Reagan, my dad, and all my family and friends in the community who have helped make me and the place we live in so wonderful. Also, a special acknowledgment to my mom, whom I lost at age 12; she continues to be in my heart and mind every day, and I hope that if she were here, she would be proud.

—*Michael*

Copyright © 2021 by Michael Anderson and Ashley Sedlak-Propst
ISBN 978-1-4671-0730-3

Library of Congress Control Number: 2021938108

Published by Arcadia Publishing
Charleston, South Carolina

Printed in the United States of America

For all general information, please contact Arcadia Publishing:
Telephone 843-853-2070
Fax 843-853-0044
E-mail sales@arcadiapublishing.com
For customer service and orders:
Toll-Free 1-888-313-2665

Visit us on the Internet at www.arcadiapublishing.com

ON THE FRONT COVER: The P.M. Morris building stands prominently on Union Street, linking the past to the present with its mostly unchanged façade. The historic building, constructed around 1900, once housed the Hotel Normandy and the Cabarrus Bank, as well as Warren C. Coleman's general store. Recently, the building was used as a location in the 2021 filming of *Are You There God? It's Me, Margaret,* a movie based on the novel of the same name by Judy Blume. (Past, courtesy of Historic Cabarrus Association Inc.; present, courtesy of Michael A. Anderson Photography.)

ON THE BACK COVER: Mule-drawn buckboards and wagons loaded with cotton from local farms form a line on Union Street in front of the 1876 courthouse, waiting their turn to weigh their cargo at the scales on Market Street. (Courtesy of Historic Cabarrus Association Inc.)

CONTENTS

ACKNOWLEDGMENTS

First and foremost, this book would not have been possible without the expertise and mentorship of Jim Ramseur. He has provided valuable historical insight through the years, and there is no person more knowledgeable about downtown Concord and its history. Acknowledgment and thanks must be given to all the local historians, past and present, who paved the way for us to continue to share and learn from our past. The Honorable Clarence E. Horton Jr., Michael Eury, J.K. Rouse, Bernard Davis Jr., Bernard Cruse, Peter Kaplan, Helen Arthur-Cornett, the Lore sisters, and so many others have diligently preserved the history of Cabarrus County. To the board of directors of Historic Cabarrus Association Inc., the members and leaders of the Cabarrus Genealogy Society, and to Leslie Kessler and Denise McLain at the Lore History Room in the Cabarrus County Public Library, thank you for your expertise and your continued dedication to helping local people tell their stories.

Thanks go to Michael Anderson, the co-author of this book, who took charge of over a century's worth of photographs in the historic Lawson Bonds photography studio. Special thanks go to Zack Roberts and Lawson Bonds for having shot and saved amazing photographs of Concord during the 20th century, and to Lawson's wife, Maxine "Mac" Bonds, for her support of Michael's tireless work to catalog and save those photographs. Special recognition must also be given to every person who came to the Lawson Bonds studio to help go through and catalog the photographs after their discovery.

Many heartfelt thanks and lots of hugs go to our families and friends who supported us throughout the process of putting this book together. Special thanks go to my husband, Bradley Propst, for riding around Concord with me to hunt down some of the harder-to-find locations for this book. And last but certainly not least, thank you to the amazing people of Concord, both past and present, whose stories are a part of our shared history and have helped make this town a unique, diverse, and wonderful place to live.

Unless otherwise specified, all past images appear courtesy of Historic Cabarrus Association Inc. and all present images appear courtesy of Michael A. Anderson Photography.

INTRODUCTION

On April 12, 1936, Cabarrus County's only morning newspaper, the *Herald-Observer*, printed a special edition publication that showcased the booming growth of Concord and Cabarrus County. "Cabarrus County bids you welcome," the headline announced.

When they hear the name Concord, most people immediately think of two things: Concord Mills Mall and the Charlotte Motor Speedway. Both attractions draw hundreds of thousands of visitors each year. However, few who travel Interstate 85 north to Greensboro or south to Charlotte are aware of the vibrant and historic downtown that exists just three miles off the interstate.

Concord's history dates to the late 1700s, when German and Scotch-Irish settlers disagreed over where the county seat for the newly formed Cabarrus County should be. Scotch-Irish settlers wanted it to be closer to the western side of the county, while Germans had settled farther east. Eventually a compromise was made, and 26 acres were purchased by John Means and Leonard Barbrick for $62.30. The town was named Concord, which meant "harmony," and the main street through the tiny hamlet became Union Street in honor of the compromise between the county's citizens.

From an agriculturally focused beginning to the boom of textiles and industry in the late 19th and early 20th centuries, Concord experienced the evolutionary growing pains that most small southern towns faced. The latter part of the 20th century brought an economic downturn as textile mills closed or moved overseas. Industry and business moved closer to the interstate for convenience, and downtown began to fade.

The economic hardships of the 1990s and early 2000s could not dampen the thriving spirit of Concord and its people. New businesses have moved into the historic downtown, and the population has boomed in the past decade. Concord is now the 10th largest city in North Carolina and is home to almost 100,000 people. Downtown Concord is representative of dozens of other small textile towns that have faced adversity and come out the other side stronger and unified. There is a unique and beautiful blending of history and progress happening in Concord, and today, the town and its people bid you welcome.

A MODERN, SOUTHERN CITY

DOWNTOWN AND DAILY LIFE

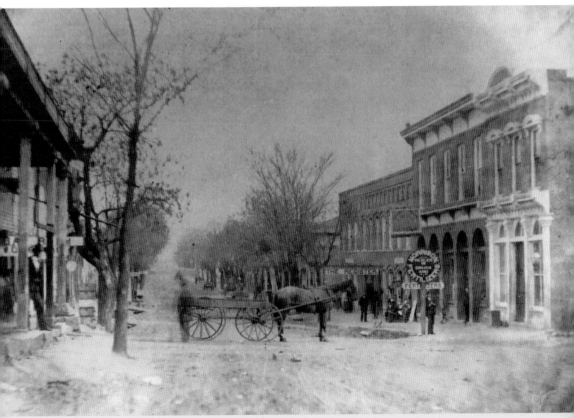

This is one of the earliest known photographs of downtown Concord. Believed to have been taken in the mid-to-late 1870s, it shows Union Street, the main thoroughfare through downtown, looking south. The horse-drawn wagon sits in the city square, the intersection of modern-day Union Street and Cabarrus Avenue. Concord's historic business district stretches from modern Corban Avenue to Cabarrus Avenue; however, growth in the 20th century carried local businesses east and west on Cabarrus Avenue and onto Church Street.

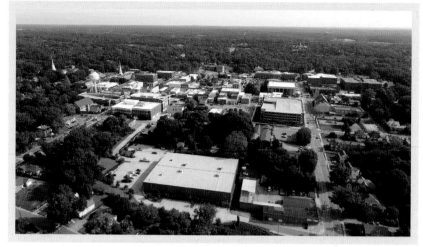

Aerial photographs of downtown Concord are not a new concept. In the early 20th century, photographs were taken from small planes that showcased the residential and downtown streets from above. Today, drones have replaced planes, and the footprint of downtown Concord has grown exponentially. The historical aerial view showcases the whole of downtown Concord's business district in the 1950s. The green space at lower left is Memorial Gardens. The modern photograph shows a slightly wider view. The large blue building in the foreground is Carolina Courts, and Memorial Gardens and the rest of downtown are just beyond. (Past, courtesy of the Lawson Bonds Studio Collection, Michael A. Anderson Photography.)

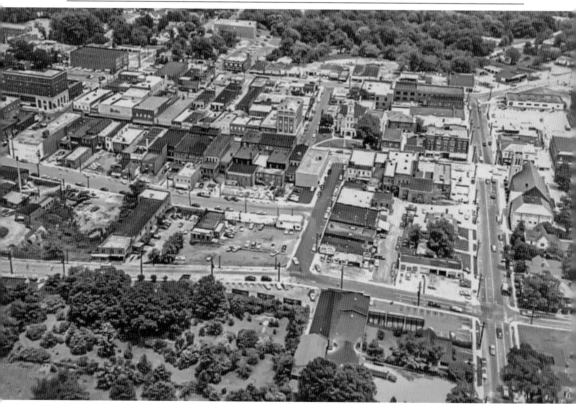

A MODERN, SOUTHERN CITY

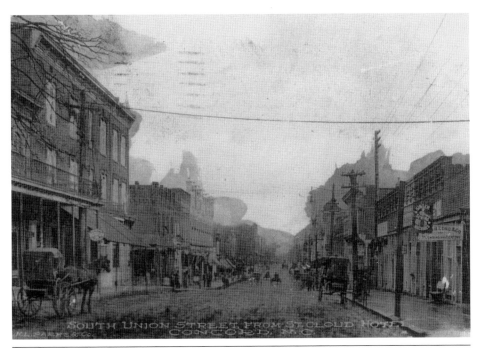

This c. 1910s photograph shows an unpaved Union Street looking south. On the left is the St. Cloud Hotel, now the location of Buzz City Games and the Hotel Concord. The buildings on the right housed a Singer sewing machine shop as well as a plumbing and heating store. Past the hotel, the tallest building on the east side of Union Street was Cannon & Fetzer Company. James William Cannon, the founder of Cannon Mills, was a founding partner of the department store that served Concord in the early 20th century.

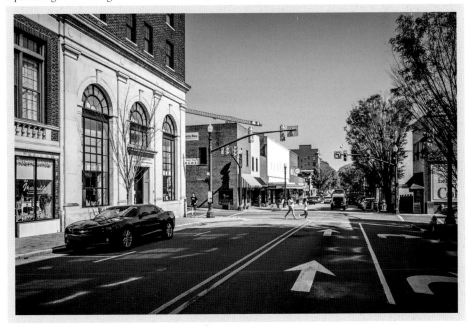

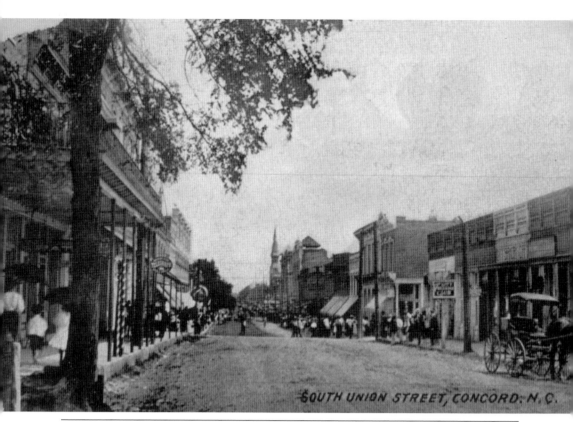

This photograph, taken from in front of the St. Cloud Hotel, shows Union Street looking south and a better perspective of the buildings on the west side of the street. At the time, the buildings on the right housed a café, hardware and repair stores, a drugstore, and the *Concord Register*, which operated from 1875 to the mid-1880s. Today, these buildings house Bottle & Can, the Bead Lady, a travel agency, Press and Porter Coffee Shop, Goldberry Books, the Basement Arcade Bar, and Gianni's Trattoria. The tall spire in the background is the 1880s St. James Lutheran Church.

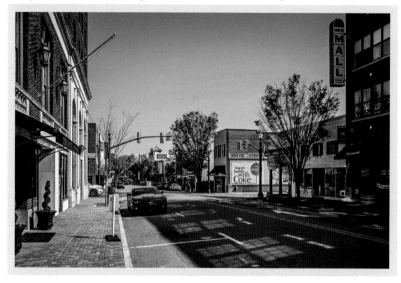

A MODERN, SOUTHERN CITY

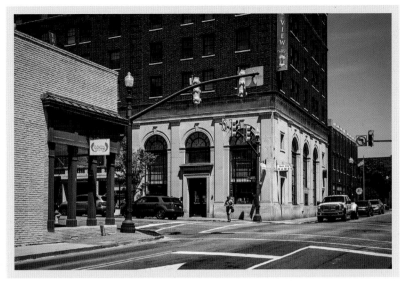

This c. 1889 photograph shows the Concord street railway passing in front of the St. Cloud Hotel. The hotel was relatively new in the 1880s and was a popular gathering place for visitors. Guests are visible on the balcony, which was accessed through a single window that is almost hidden by the steam of the engine. On the bottom floor of the hotel, three men are standing in front of the Concord National Bank. Today, the Hotel Concord stands in the same location, and the former Concord National Bank is now a gaming store.

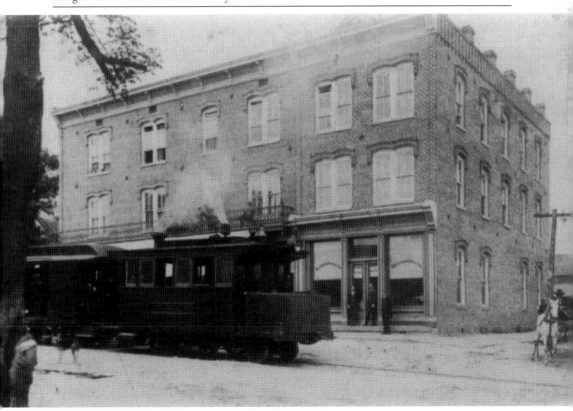

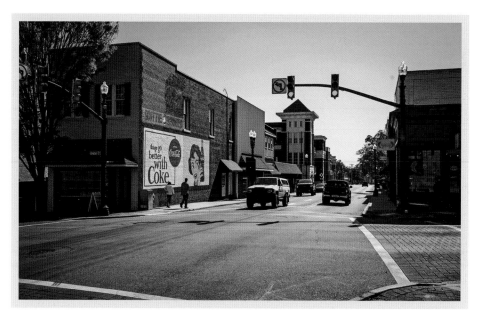

Concord's electric streetcar service began on April 24, 1911, and provided transportation from downtown to the train station just west of downtown for 14 years. The photograph from the early 1910s showcases the streetcar preparing to turn south on Union Street. Today, the streetcar lines no longer exist, and the street name has been changed from Depot Street to Cabarrus Avenue.

Before Davis Drug occupied the building on the left, it was Fetzer Drugstore. Today, a travel agency occupies the building. Of special note are the ghost signs visible on the side of the building. A faint Coca-Cola sign can be seen at the top of the structure, and at street level is a vintage Coca-Cola advertisement that was restored in 2015.

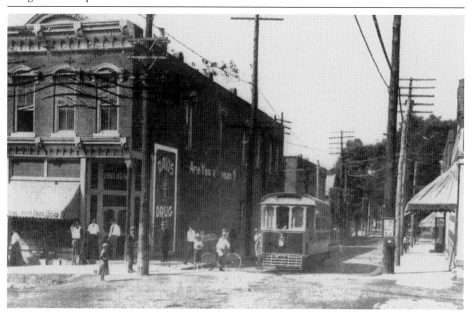

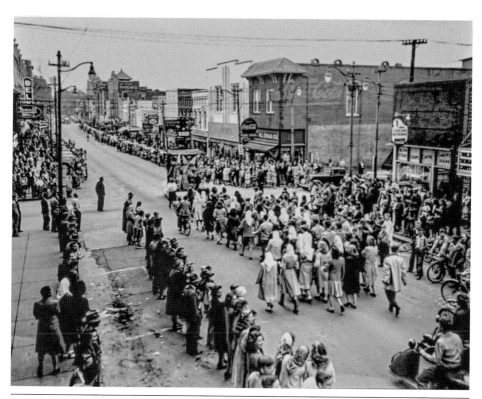

Downtown has always drawn people from near and far. Parades and festivals are still an important part of downtown Concord's vibrant personality. In 2021, the Concord Christmas Parade will celebrate its 93rd year, with hopes for another century of celebrations to come. (Past, courtesy of the Lawson Bonds Studio Collection, Michael A. Anderson Photography.)

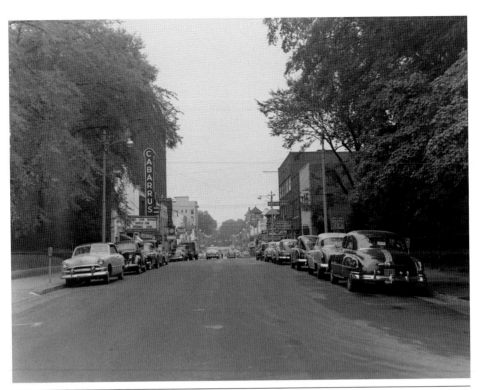

This 1950s photograph shows another view of Union Street looking south. On both sides of the street, the buildings have remained largely unchanged. The façade of the Cabarrus Theatre was replaced with brick, and there are plans underway in 2021 to replace the marquee on the front of the building. On the right side of the street, the Cannon Building housed Western Union, the Center Theatre (formerly Paramount), M.R. Pounds Cleaners, and the Luncheonette (a downtown eatery), along with offices for physicians and real estate offices on the upper floors. (Past, courtesy of the Lawson Bonds Studio Collection, Michael A. Anderson Photography.)

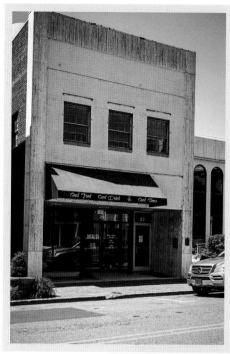

Kale-Lawing Co. was a long-standing business downtown. Originally founded in Charlotte, the office supply store had three different addresses in Concord between the 1930s and its closing in the 1980s. The final location was 21 Union Street North, now 25 Union Street North. The house to the right of Kale-Lawing was torn down in the 1970s to make space for the Concord Public Library's new building. (Past, courtesy of the Lawson Bonds Studio Collection, Michael A. Anderson Photography.)

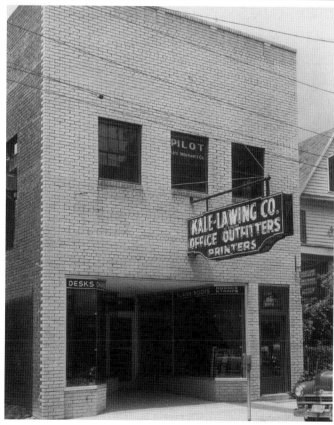

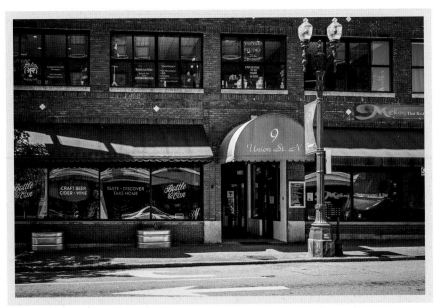

The Cannon Building, erected in the early 1920s, was funded by Joseph F. Cannon and contained stores, offices, and a two-story theater with a massive arched stage in the rear. In the 1930s and 1940s, the Paramount Theatre drew large numbers of patrons by inviting traveling actors to promote their movies, mostly Westerns, at the theater. Today, the arched stage has been hidden, although some of the original details can still be seen on the second floor. The upstairs rooms are still used as office and retail space.

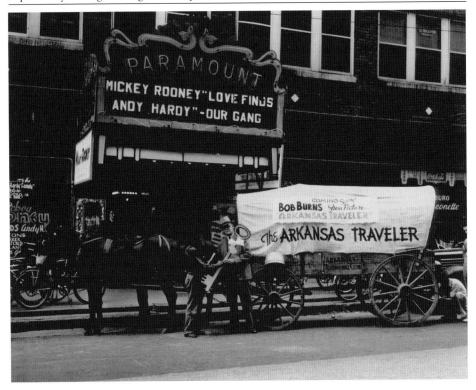

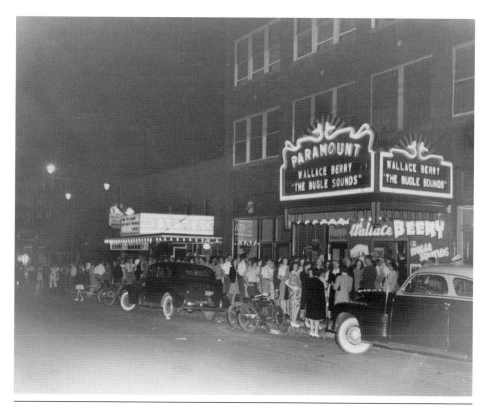

Approximately 17 theaters have operated in and around downtown Concord since the late 19th century. To the left of the Paramount theatre, and just down the street from the Cabarrus Theatre, the State Theatre began as the Star Theatre and was renamed sometime before 1940. Today, the building houses ShoeBeeDo, a handmade shoe and leather goods store.

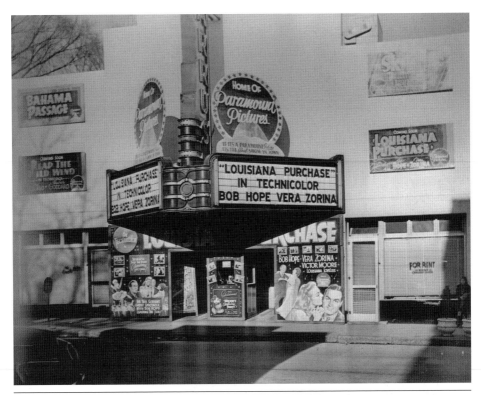

Just north of the Hotel Concord stood the Cabarrus Theatre, which opened on June 19, 1939, and operated into the early 1980s. Today, the original Art Deco façade of the building has been replaced by brick and the interior of the structure has been drastically changed. The building is currently being renovated for multi-purpose use, and there are plans to restore and replace the iconic Cabarrus marquee.

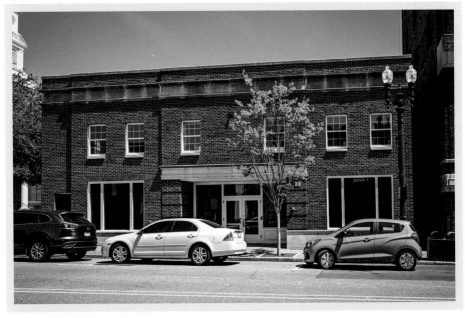

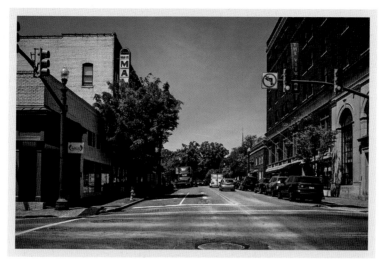

This mid-1920s photograph, taken from the square, showcases an early view of the northwest block of Union Street. The Star Theatre, later the State Theatre, is at front left. The very bottom of a theater marquee is visible on the building to the right of the Star. Prior to being the Paramount Theatre, the Concord Theatre was the first to operate inside the Cannon Building.

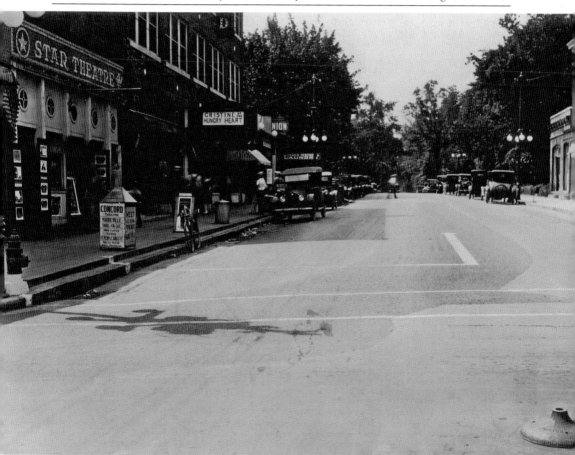

A prominent structure in downtown Concord is the Hotel Concord, at the corner of Cabarrus Avenue and Union Street. The six-story Beaux-Arts Classical Revival building was erected in 1925, replacing the St. Cloud Hotel (sometimes also spelled St. Claud Hotel). The first-floor area of the building also housed the Concord National Bank, originally founded in 1888. The original vault for the bank is now a focal point inside Buzz City Games, a board game and card store. Today, the Hotel Concord ballroom is a popular venue for weddings and events, and the original hotel rooms have been renovated and expanded into apartments. Across Depot Street (modern-day Cabarrus Avenue) is Gibson Drug Store. Today, the Chocolatier Barrucand, a well-loved local sweet shop and bakery, offers delicious treats and gorgeous cakes to patrons.

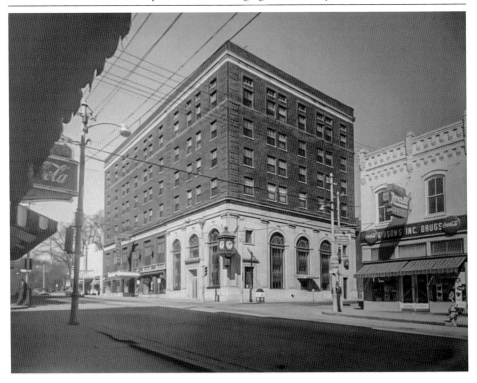

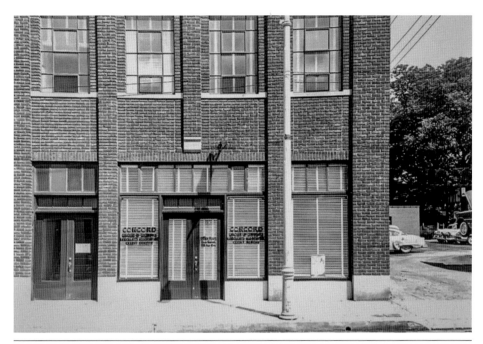

In 1939, the Concord Telephone Company, originally founded in the back of the Concord National Bank, remodeled two buildings at 11–15 Cabarrus Avenue to house its offices. The two buildings were originally built in 1908 and 1916. The Art Deco elements on the building still remain. Today, the Sweet Life, a locally-owned bakery, is on the ground floor of building.

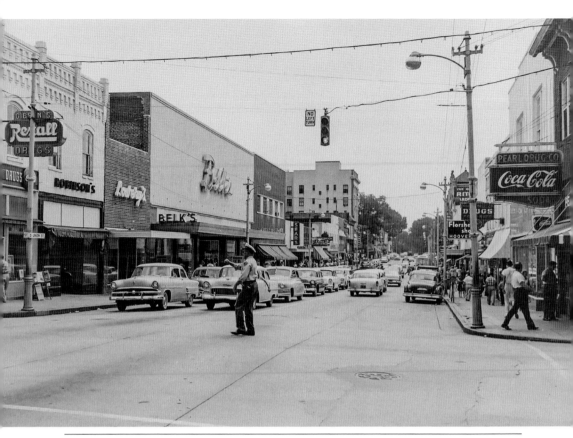

The City Square of downtown Concord is a lively intersection where Union Street and Cabarrus Avenue meet. This view, looking south on Union, illustrates the vibrancy of downtown Concord in both the late 1950s and today. Drugstores and department stores have been replaced by restaurants, boutiques, and other locally owned businesses, but the same energy is still apparent downtown.

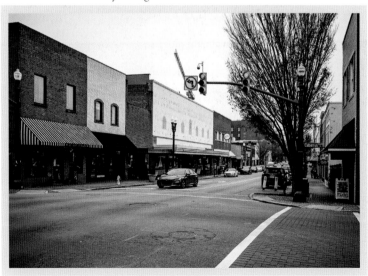

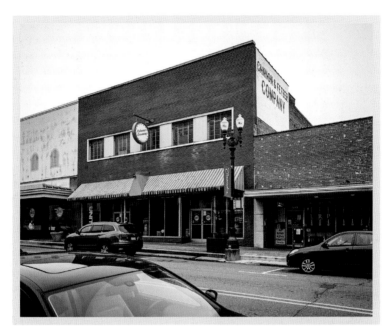

Like much of downtown, the front of 21 Union Street South has changed over the years. Much of the original façade of the Cannon & Fetzer building was replaced in the mid-20th century. McLellan's Department Store was nestled between Belk's and Sears, meaning downtown shoppers had plenty of options in the 1960s. Today, the modern Cabarrus Creamery is on the ground floor, and Red Hill Brewing occupies the second story.

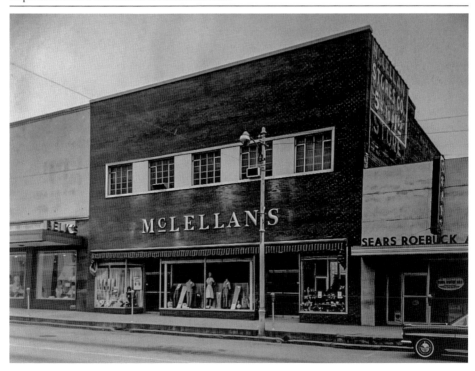

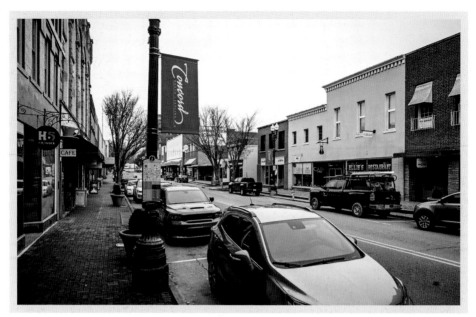

This 1950s street view shows South Union Street looking north toward the city square. The Hotel Concord rises tall in the background. Today, the businesses and restaurants have changed but still draw in customers both local and visiting on a daily basis. The Cannon & Fetzer Company ghost sign has been meticulously restored from historical photographs of the building, replacing the McLellan sign that was painted over it. (Past, courtesy of the Lawson Bonds Studio Collection, Michael A. Anderson Photography.)

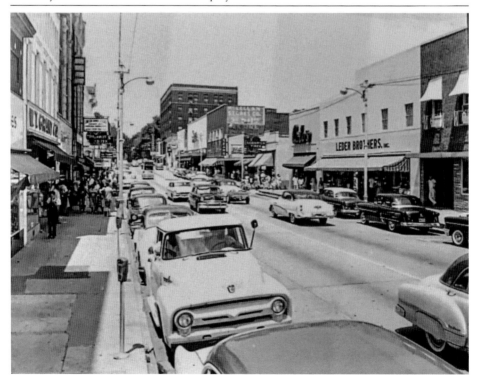

A MODERN, SOUTHERN CITY

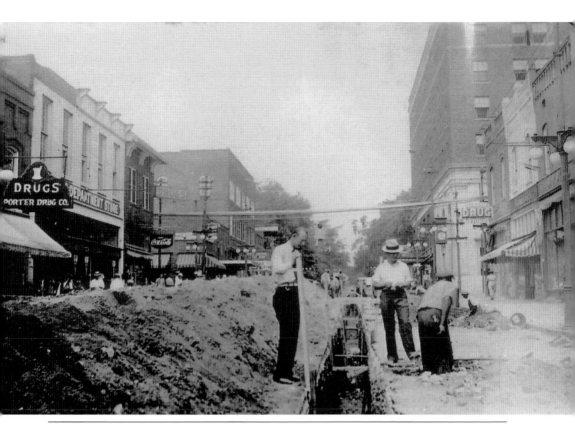

Every city goes through growing pains. This photograph from the 1940s shows Union Street under construction. A portion of the center of the street is being worked on, perhaps for water or sewer lines. Porter Drug Co., Efird's Department Store, and Davis Drugs are on the left, while Gibson Drug Store and the Hotel Concord are on the right.

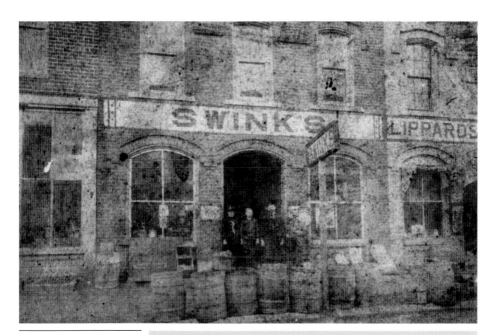

The façade of 14 Union Street South has undergone several changes over its lifetime. At the time of this first photograph, the building, constructed in 1878, housed the Swink Brothers general store. The entry level was recessed sometime in the early 1900s, and several jewelry stores and antique stores operated in the building throughout the 20th century. Today, the original façade has been restored, and downtown visitors and locals alike enjoy playing retro arcade games and pinball at the Basement Arcade Bar. Next door, the former Lippard's and Barrier General Store, which has served as several different businesses over the last century, is now home to Goldberry Books.

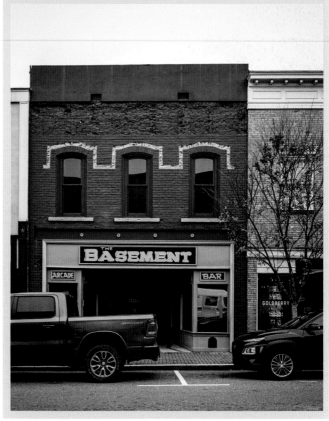

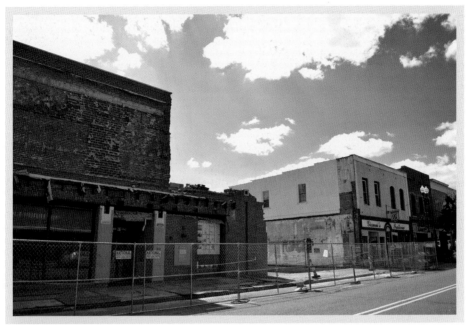

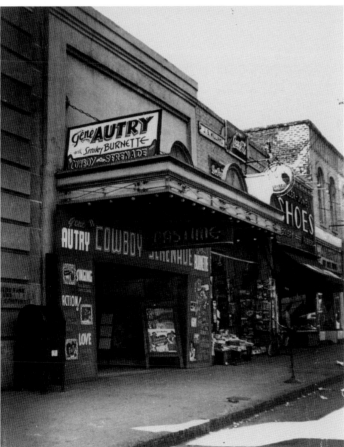

The Pastime Theatre was yet another popular movie theater on Union Street. To the left of the theater is the Citizens Bank and Trust Company. In the late 20th century, these buildings were converted for use as City of Concord offices. As of spring 2021, the old city buildings were under demolition to make way for new progress and exciting changes in downtown. (Present, Ashley Sedlak-Propst.)

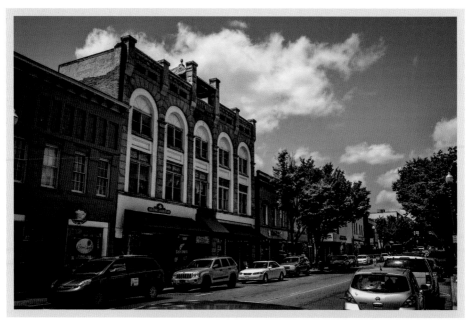

Located at 36–40 Union Street South, the Pythian Building is one of the best-preserved buildings from the turn of the 20th century downtown. Erected in 1902 by the Pythian Realty Company, it was designed to host storefronts on the ground floor, office space on the top floor, and a large meeting hall for the Knights of Pythias and other fraternal groups. The ground floor housed Ritchie Hardware Company for several decades. The unique open pavilion on the roof can be seen from almost anywhere in downtown Concord. Today, the building houses photography and dance studios, offices, the Enchanted Kitchen, and a workout studio.

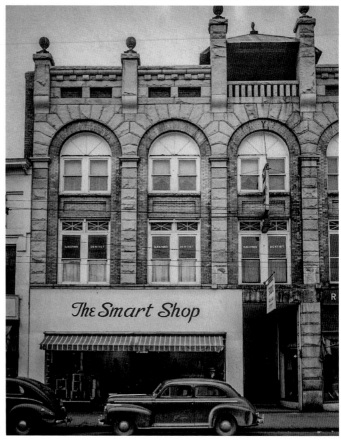

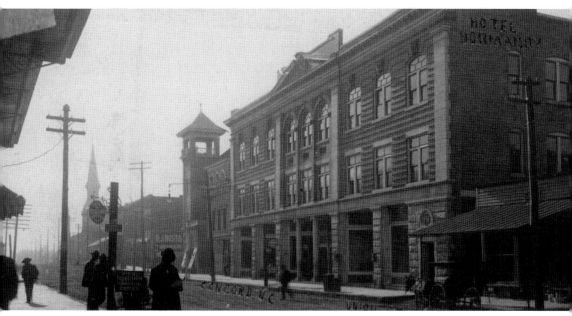

Here is a view of South Union Street at the beginning of the 20th century. The P.M. Morris building, constructed around 1900, stands prominently on Union Street. The building once housed the Hotel Normandy and the Cabarrus Bank, as well as a general store owned by Warren C. Coleman, a prominent African American businessman. Today, Ti-Sun beauty supply store and the Union Street Bistro are on the ground floor, with various businesses and studios filling the second- and third-story spaces.

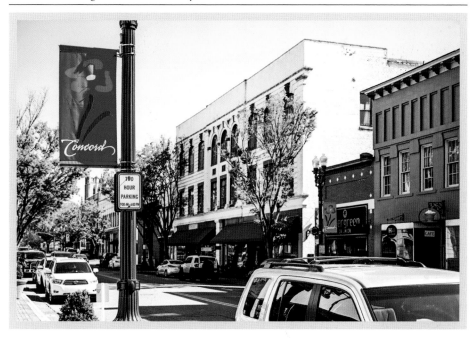

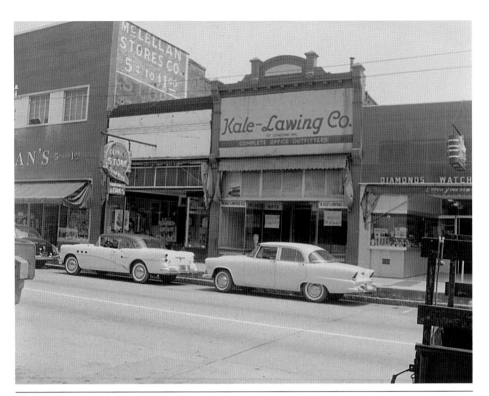

This block of buildings on Union Street has not changed much through the years. The present-day location of the Cabarrus Creamery's storefront was once the McLellan's 5¢ to $1 department store. The McLellan ghost sign has been replaced with the original Cannon & Fetzer Company sign. Cline's Store is now a popular watering hole, and Lil' Robert's Place and the Kale-Lawing Company office supplies store became Neta's clothing shop, which operated until 2019, when the Concord icon retired. Robert Burrage Jr. has expanded his taproom into Neta's former space. Ellis Jewelers is still in its same location and continues to provide excellent service to downtown. (Present, Ashley Sedlak-Propst.)

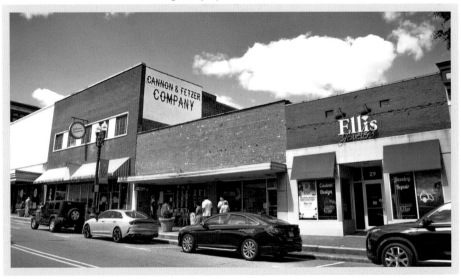

A MODERN, SOUTHERN CITY

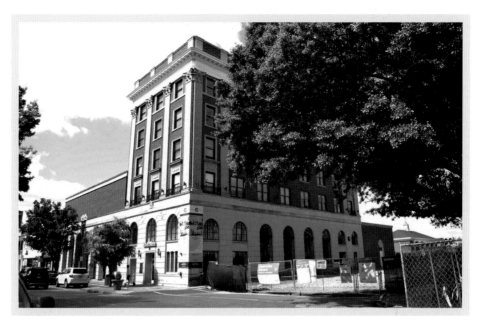

Established in 1897 with help from James William Cannon, the Cabarrus Savings Bank began in the P.M. Morris building. The bank erected this six-story Beaux-Arts Classical Revival building in 1923, opening branches in Albemarle, Mt. Pleasant, and Kannapolis over the following decade. The bank eventually became First Citizens Bank before passing into private ownership in the 1990s. The building recently reopened as the Cabarrus Center, offering co-working space and meeting rooms. (Present, Ashley Sedlak-Propst.)

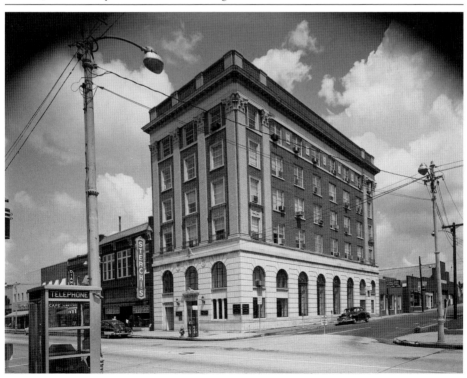

This is a view of Union Street looking north from the 1876 courthouse. The prominent building on the left is the 1903 Concord City Hall, which housed the fire department on the first floor. The tower included a bell that would ring whenever the firemen were needed. The structure was demolished in the mid-20th century. The modern city hall on Cabarrus Avenue includes a tower in tribute to its 1903 predecessor. The building to the right of the town hall housed a billiard saloon, a cigar and tobacco shop, and various other businesses through the years. The P.M. Morris building and the Pythian Building are prominent on the left side of the street, while the Cabarrus Savings Bank and the Hotel Concord are most prominent on the right.

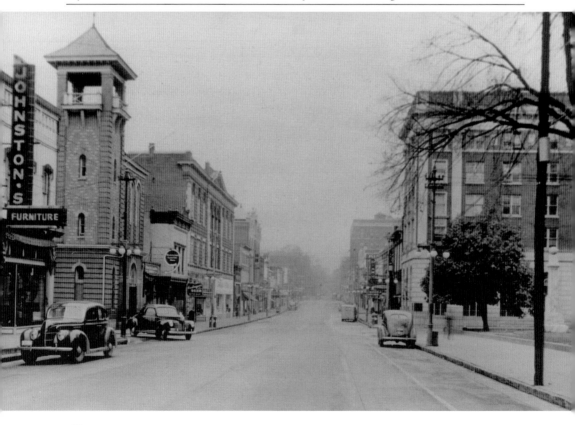

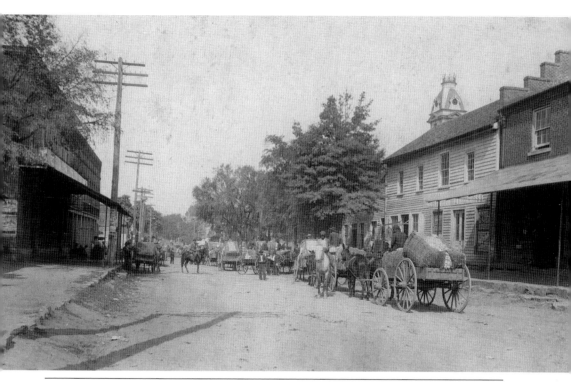

Pictured here is a c. 1898 traffic jam on Union Street. These scenes show Union Street looking north from the intersection of modern-day Corban Street. Mule and horse-drawn buckboards line up in front of the 1876 courthouse waiting to turn down Barbrick Street, where their cotton bales could be weighed. Two-story wooden buildings lining Union have been replaced by the 1970s Cabarrus County Courthouse. The clock tower of the 1876 courthouse is visible over the top of the white wooden structure on the right. The redbrick building on the left was erected in the late 1800s and remodeled to its current appearance sometime around 1906. The Concord Post Office and a pharmacy once occupied the ground floor, and in 1921, the Concord Tribune and Times Printing Company moved in. Today, 2 Gals Kitchen, a popular eatery, and the Escape Artist, an escape room attraction, are on the ground floor.

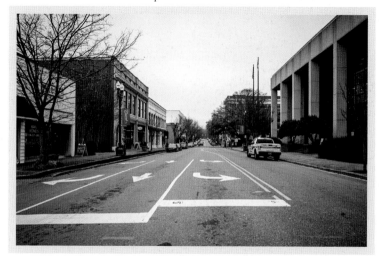

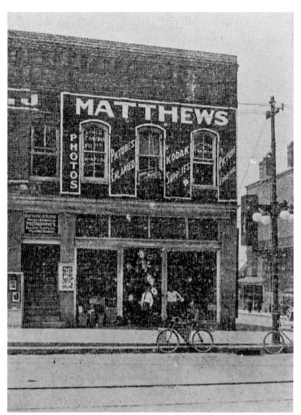

Matthews Photography was just one of many photograph stores on Union Street. The studio was housed on the second floor of the building with shop space on the ground floor. Today, the building, at the corner of Union Street and Barbrick Avenue, houses gallery space downstairs and a cigar lounge on the second story.

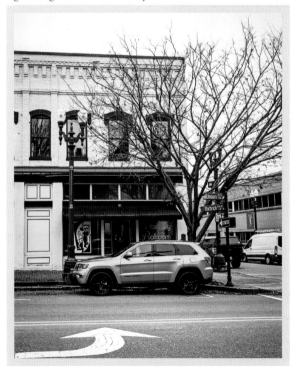

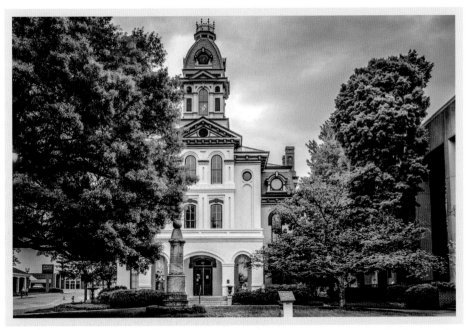

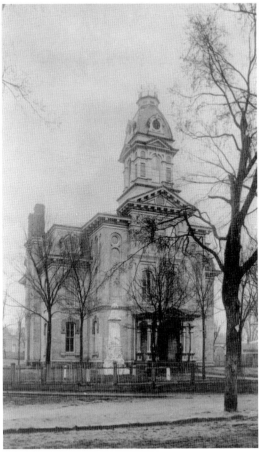

From a courthouse to a cultural center, the 1876 courthouse has witnessed amazing things over the past century. Today, the Cabarrus Arts Council and Historic Cabarrus Association share the space once occupied by the courtroom and offices. The Cabarrus Arts Council showcases local and regional artists and world-renowned musicians, and Historic Cabarrus Association tells the history of Cabarrus County through rotating exhibits. Historic Cabarrus was founded in the 1970s to help save this building from demolition.

Between 1897 and 1906, prominent Concord businessman John Phifer Allison constructed the Allison Block. At the time, it was one of the largest buildings in downtown Concord. Through the years, the Allison Building housed A.F. Hartsell Company, a wholesale grocery store, as well as a shoe hospital, Kimbrell's furniture store, an appliance store, Kale Lawing Company, and Zack Roberts's photography studio. The building was torn down to make room for the construction of the new Cabarrus County Courthouse in the 1970s. The clock tower of the historic 1876 courthouse can be seen to the left of the Allison Building.

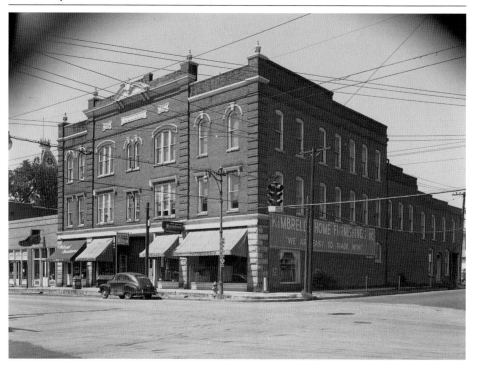

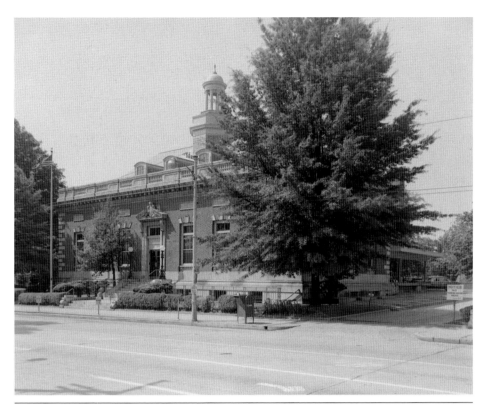

The US Post Office Department established the Concord Post Office on May 20, 1819, and Silas Travis was named postmaster. The local post office has been in continuous operation since 1819, and around 1911, an elaborate new building was erected on South Union Street. Renovations were done in the 1940s to the interior of the post office, but it was demolished in the latter part of the 20th century, and a new post office was built on McEachern Avenue. The site of the 1911 Concord Post Office is now part of the parking lot for St. James Lutheran Church. (Present, Ashley Sedlak-Propst.)

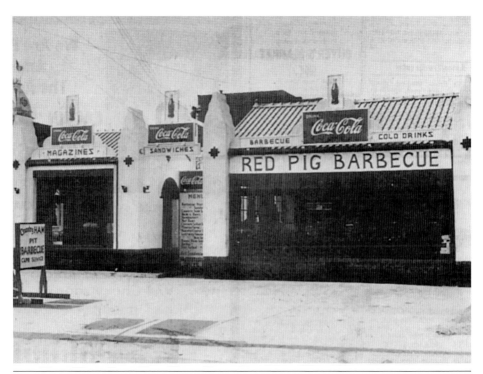

What is a North Carolina town without a barbecue joint? Mill workers flocked to the Red Pig Barbecue after their shifts for what was considered to be "the best barbecue in North Carolina." One local man hitchhiked from San Francisco while on leave from the US Navy just to have a taste of the Red Pig's famous sliced barbecue. The restaurant moved several times over its lifetime and closed its doors in the early 2000s. The first location is now home to Rotary Square and the Cabarrus County sheriff's office. This version of the Red Pig sat near the corner of Means Avenue and Church Street; the clock tower of the 1876 courthouse is at far left. Today, local hamburger chain What-A-Burger, not to be confused with the Texas Whataburger, sits in a similar location. These days, Troutman's Bar-B-Q on Church Street is the go-to barbecue joint in town.

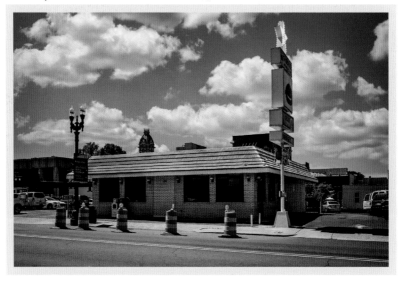

A MODERN, SOUTHERN CITY

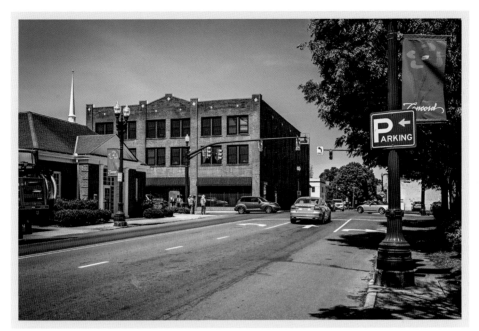

The property at 29 Cabarrus Avenue East, at the corner of the former Depot Street and Church Street, began its life as the Maxwell Brothers Furniture Company around 1921. Through the years, the building served as Heilig Meyers Furniture and was renovated in the 2010s into Lofts 29, which houses 26 luxury apartments in the heart of downtown.

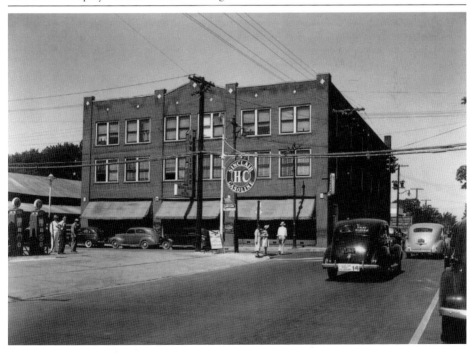

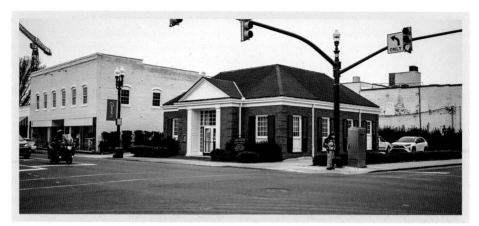

The corner of Church Street and modern-day Cabarrus Avenue was once a central location for auto lovers. Reid Motor Company operated a Ford and Ferguson dealership, as well as an Esso service station. In 1955, Bart O'Neal and Grady Shoe bought out Reid Motor Company and formed Shoe-O'Neal motors, which continued as a Ford dealership. Today, the original dealership houses Habitat for Humanity's Cabarrus offices and the Concord Trophy Center. The Esso station was torn down, and the building that replaced it is now the law offices of Koontz, Hawkins, Nixon, & Miller.

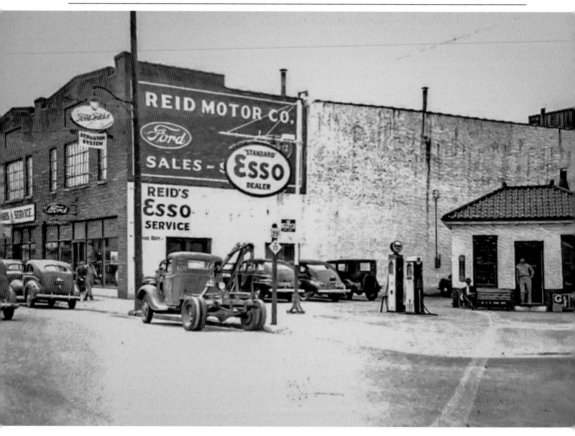

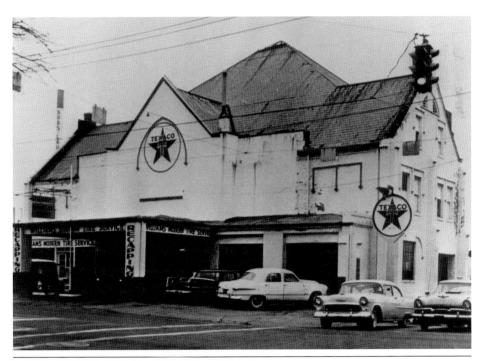

These photographs are just one example of the changing face of downtown. In the 1950s, Williams Modern Tire Service sat at the corner of Cabarrus Avenue and Spring Street. The station had been remodeled heavily from its original use as the 1904 sanctuary for First Presbyterian Church. The steam stack for Bob's Laundry is visible at upper left. Today, the Concord Police Department and Town Hall occupy the block.

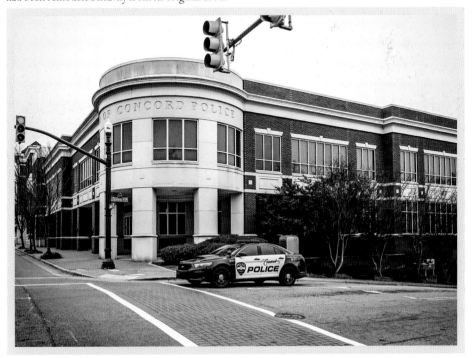

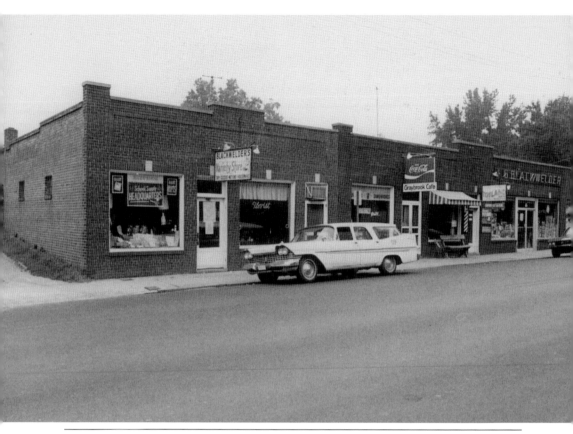

McGill Avenue, heading northwest out of downtown, is in the Gibson Mill village area. In the 1940s and 1950s, H.G. Blackwelder and other locals opened a series of retail stores on this block to serve the neighborhood. From left to right are Blackwelder's Variety Store, the Bouquet Shop, Graybrook Café, Blackwelder's Toyland (a favorite among local kids), and Blackwelder's Grocery. Today, the storefronts stand vacant, but nearby revitalization at Gibson Mill holds out the promise of a new life for this brick structure.

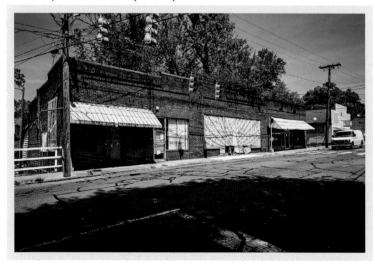

A MODERN, SOUTHERN CITY

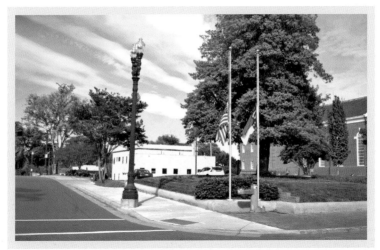

Standing at the corner of Union Street and Holly Lane (modern-day Killarney Avenue), this building began its life as the private home of attorney William A. "Sandy" Smith in the late 1860s. Smith is credited with building the first sidewalk in downtown Concord in 1891 in front of his home. The property was sold in 1916, and the house was converted into a YMCA. A pool and gymnasium were added to the house, as well as meeting rooms. In 1939, the city hired architect A.G. Odell Jr. to design a community center using the bones of the Smith house. In 1940, the Concord Community Center opened and housed the Concord Library, the Memorial Hall Museum (present-day Historic Cabarrus Association Inc.), and the community pool. The building also housed the Concord Canteen, a gathering place for soldiers during World War II. The structure was demolished in 1977, and the new library was built across Union Street. The Concord Museum moved to the 1976 courthouse, and the parking lot for Central United Methodist Church now sits where the community center once stood. (Present, Ashley Sedlak-Propst.)

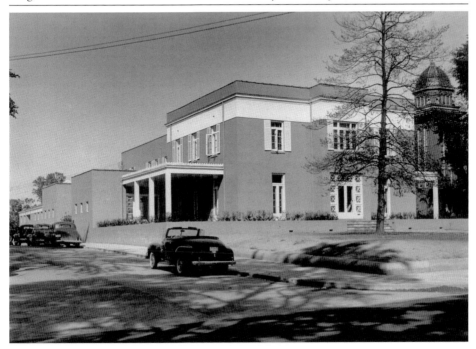

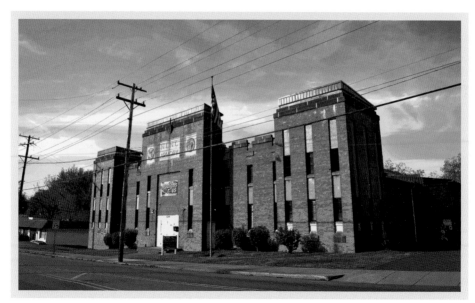

The North Carolina National Guard Armory in Concord was built in partnership with the City of Concord and the federal Works Progress Administration between 1936 and 1937. The design is identical to other National Guard armories in Salisbury and Wilson, North Carolina. Today, the structure still stands on Church Street and is home to a headlight repair shop and some employees with a unique sense of humor who left a guard on duty when the present photograph was taken. (Present, Ashley Sedlak-Propst.)

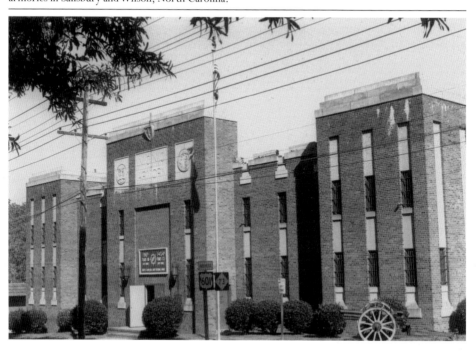

A MODERN, SOUTHERN CITY

AVENUES OF USEFULNESS

INDUSTRY, INNOVATION, AND MEDICINE

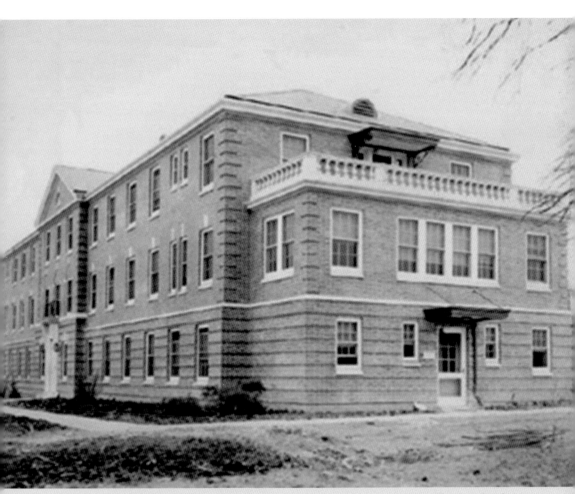

Cabarrus Memorial Hospital was opened in 1937 by Charles A. Cannon, owner of Cannon Mills, and began serving the greater Concord area. Today, the hospital is part of Atrium Health Cabarrus.

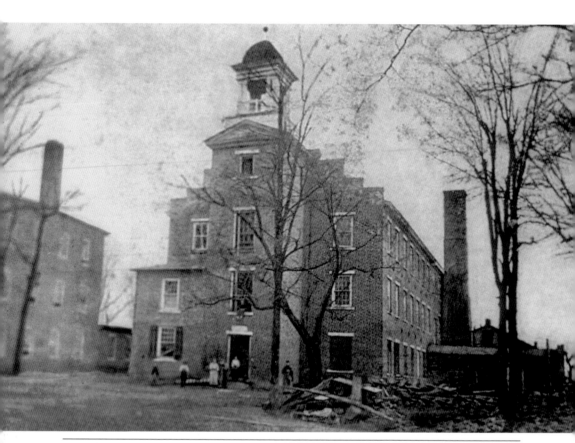

This is an early photograph of what is considered Concord's first textile mill, the Concord Steam Cotton Factory. The mill, also referred to as Concord Manufacturing Company, was begun by Paul Barringer, John T. Phifer, Daniel Moreau Barringer, and Robert Washington Allison on February 16, 1839. By 1842, it was producing cotton yarn, shirting, and nails and continued to operate through the Civil War. In 1879, the mill was purchased by John Milton Odell, who built the Odell Manufacturing Company around the existing factory. Unfortunately, most of the mill burned in August 1908. Today, Locke Mill stands on the original site. (Present, Ashley Sedlak-Propst.)

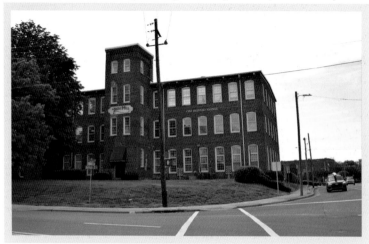

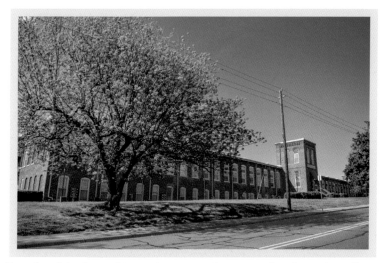

J.M. Odell purchased the Concord Steam Cotton Factory in 1879 and began Odell Manufacturing Company, which expanded the textile market in Concord and became the largest plaid mill in the South. After the 1908 fire that destroyed much of the original mill, the company declared bankruptcy and reorganized as the Locke Mill. In 1939, the mill was renamed again, as Randolph Mill. The structure faced demolition due to neglect in the 1970s and 1980s but was saved and repurposed as housing in the latter part of the 20th century. (Present, Ashley Sedlak-Propst.)

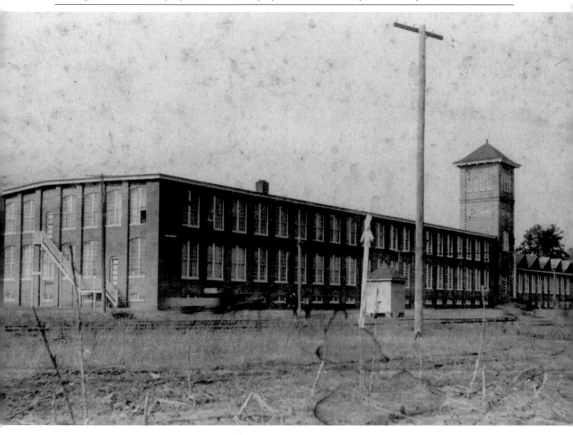

Gibson Mill was established in 1899 and became Plant No. 6 for Cannon Manufacturing Company, which had several mills and plants throughout Cabarrus County. The Gibson Mill village and many of the original homes still sit across the Southern Railway from the mill. The mill closed in 2003, and in 2004, it was purchased by a group of friends with a vision to create a gathering place for the community in the century-old building. Today, new life has emerged at Gibson Mill. An antique mall, event venues, Concord Brewing Company, High Branch Brewing, a popular escape room, and various other businesses have made the mill a popular destination. A locally sourced food hall and retail space, the Gibson Mill Market, is planned to open in 2021.

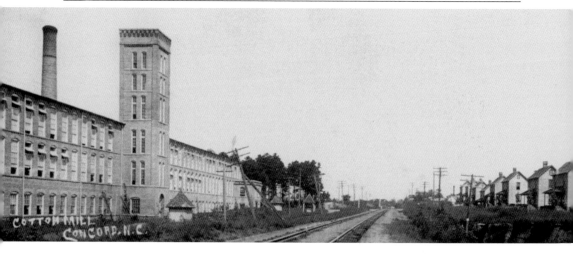

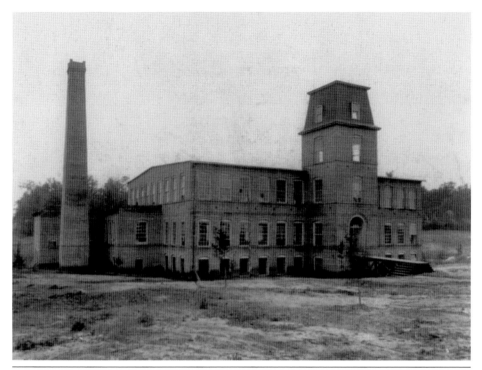

The Coleman Manufacturing Company is historically significant because it was the first mill owned and operated by African Americans in the United States. The mill was organized in 1897 by Warren Clay Coleman and a group of black businessmen. It was intended to provide jobs and economic gain for black workers who were discriminated against at white-owned mills. The mill was opened in 1901 and operated until 1904, when it closed after financial issues and Coleman's death. The mill was integrated into Plant No. 9 of Fieldcrest Cannon in the late 20th century, and in 2015, the Coleman-Franklin-Cannon Mill was listed in the National Register of Historic Places. Southern Grace Distillery, now located in Mt. Pleasant, North Carolina, started production in the Coleman Mill. Today, plans are underway to revitalize the building and turn it into housing and a community gathering place. (Present, Ashley Sedlak-Propst.)

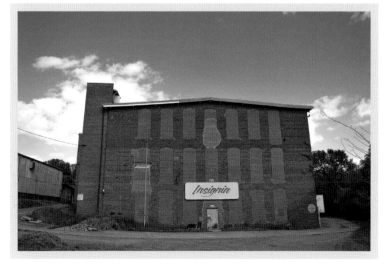

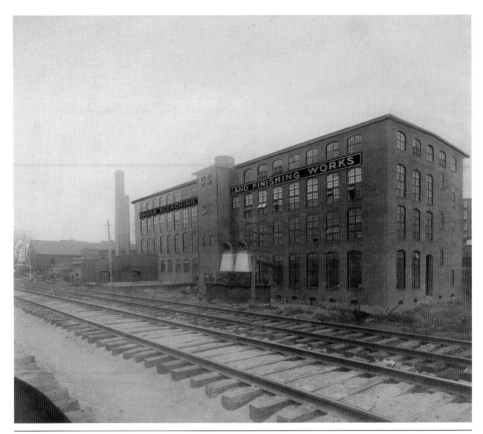

Kerr Bleachery began in the early 1890s and was partly owned by J.M. Odell and his son, who were also responsible for Odell Manufacturing Company. The original Kerr building burned in the early 1900s and was rebuilt and renamed Kerr Bleaching and Finishing Works around 1909. The mill burned down in 1979; today, the site is a storage facility for Morrison Lumber. (Present, Ashley Sedlak-Propst.)

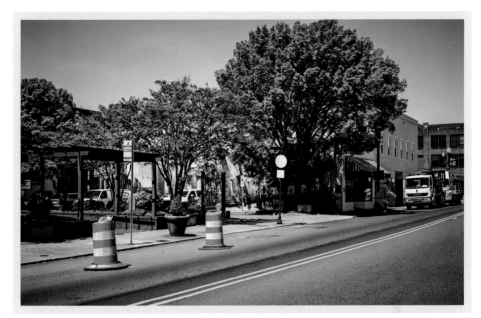

Carolina Bottling Company was established by Joseph F. Goodman in 1904 and began in this building on South Church Street. In 1911, the company erected a two-story building at the northeast corner of Church Street and Corbin Avenue. Eventually, the Coca-Cola bottling moved to a larger building on North Church Street. Today, the original building has been replaced with the Bicentennial Lot, where the Concord Christmas tree is placed each year.

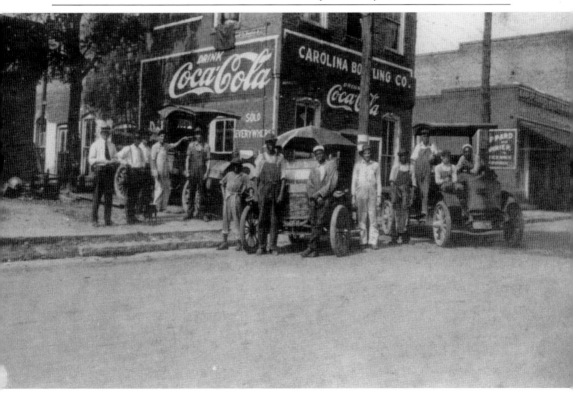

The Sun Drop company in Concord was opened in 1954 by Bill and Margaret King on Old Concord Road. The citrus soda, which was originally concocted in 1930 in St. Louis, Missouri, became a southern staple. The Sun Drop Bottling Company was sold to Cheerwine Bottling Group, based out of Salisbury, and closed in 2016 after 60 years of operation. (Present, Ashley Sedlak-Propst.)

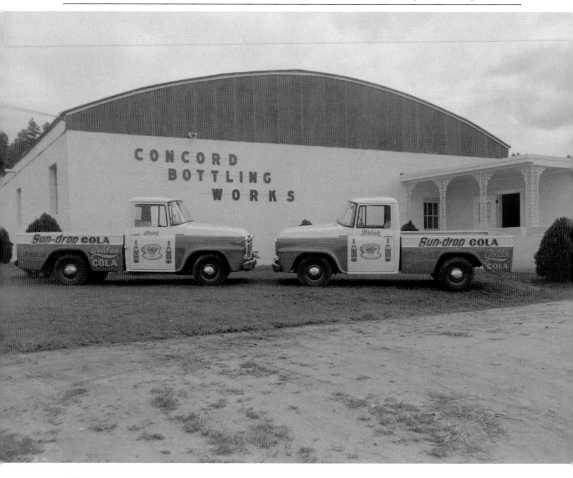

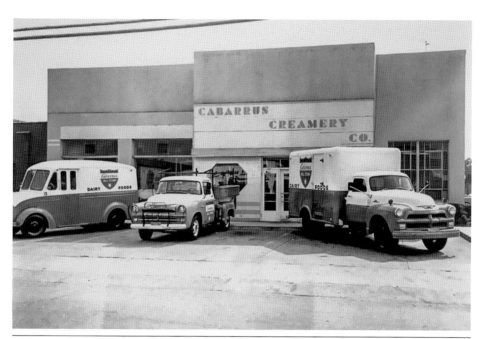

The Cabarrus Creamery broke ground on its Church Street location in 1940. The creamery was started as the Co-Operative Dairy by Robert L. Burrage Sr. in 1917 and merged with the Cabarrus Creamery Co. Inc. around 1923. Burrage and his family operated the creamery until it was sold on July 8, 1999, to Clarke Ice Cream Co. The original Cabarrus Creamery Co. closed on January 29, 2001. Fortunately, many of the recipes were revived and a storefront for Cabarrus Creamery opened in downtown Concord in 2001, serving up many of the same flavors and sweet memories it had for over 80 years. The original building on Church Street is now home to a collection of businesses and offices, including the Cabarrus County Board of Elections.

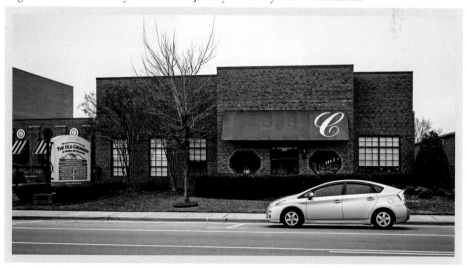

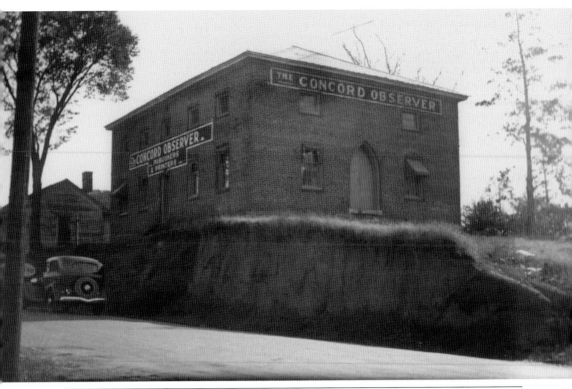

Local news has been written and printed in various locations throughout downtown over the past two centuries. This building was once the second sanctuary for First Presbyterian Church, and in the 1930s through the 1950s, it housed the *Concord Observer* and the *Concord Standard* newspaper offices. Today, the structure is gone, but visitors to Memorial Gardens can stand in this spot for an impressive view of the historic cemetery. (Present, Ashley Sedlak-Propst.)

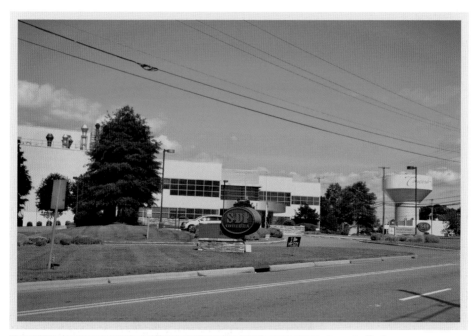

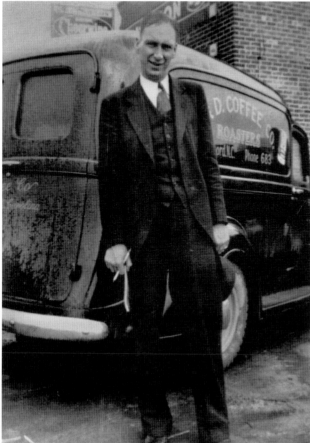

S&D Coffee began in 1927 when Roy Davis Sr. and Lawrence Switzer borrowed $500 to start a small coffee supply business in Charlotte. In 1930, the business moved to Concord, and by the 1960s, the company began to grow exponentially, expanding its distribution from small grocery stores to larger commercial industries such as restaurants, hotels, and hospitals. The company built its current manufacturing and distribution center in 2001 and has continued to distribute coffee and tea both locally and internationally. (Present, Ashley Sedlak-Propst.)

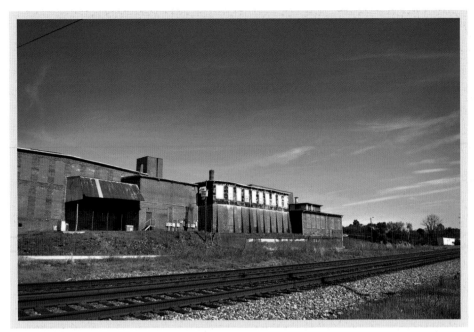

The Concord train depot was once a central hub for passenger trains traveling north to Salisbury and south into Charlotte and points beyond. The depot pictured here was constructed in 1913 and served Concord until it was demolished in 1978. Today, passenger trains make their Cabarrus County stop in Kannapolis. (Present, Ashley Sedlak-Propst.)

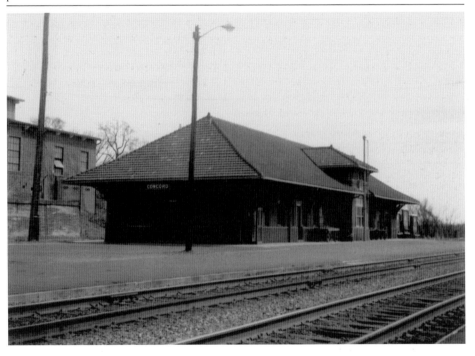

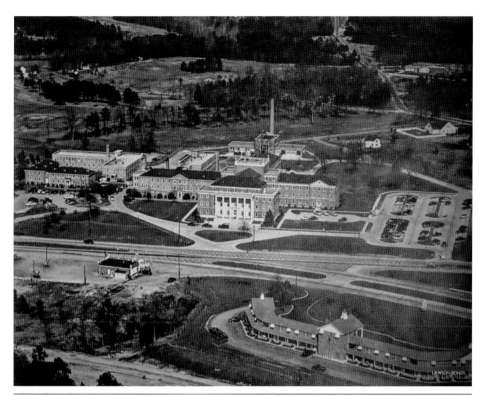

Cabarrus Memorial Hospital began as the dream of Charles A. Cannon, owner of Cannon Mills in Kannapolis. From his home in Concord, he watched ambulances transporting Cabarrus County residents north to Salisbury or south to Charlotte for emergency care. He wanted to find a way to provide affordable healthcare for his mill workers and their families, and the idea for a public hospital in Concord was born. The hospital opened in 1937 and began serving the greater Concord area. The hospital campus has grown extensively over the past century and now boasts world-class care and facilities. (Past, courtesy of the Lawson Bonds Studio Collection, Michael A. Anderson Photography.)

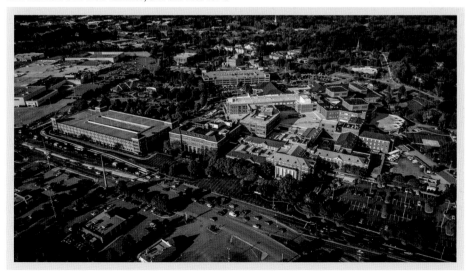

The Cabarrus County Fair has drawn visitors into town for over a century. Although the location has moved from close to downtown to a larger space further out in the county, the fantastic fair food, agricultural focus, and popular thrill rides still bring thousands of guests to town each September.

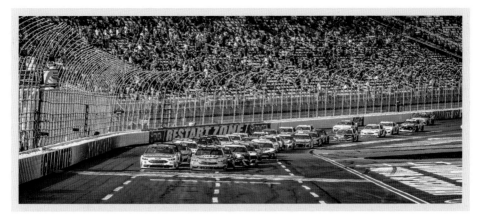

Cabarrus County is where racing lives in North Carolina. Concord is home to the Charlotte Motor Speedway, one of NASCAR's premier race tracks. Designed and built by O. Bruton Smith in 1959, the speedway has been home to some of the greatest races and hosted the most famous drivers in the sport since it hosted the World 600 on June 19, 1960. Today, the Charlotte Motor Speedway hosts the Coca-Cola 600 and the Sprint All-Star Race and draws hundreds of thousands of NASCAR fans from around the world each year.

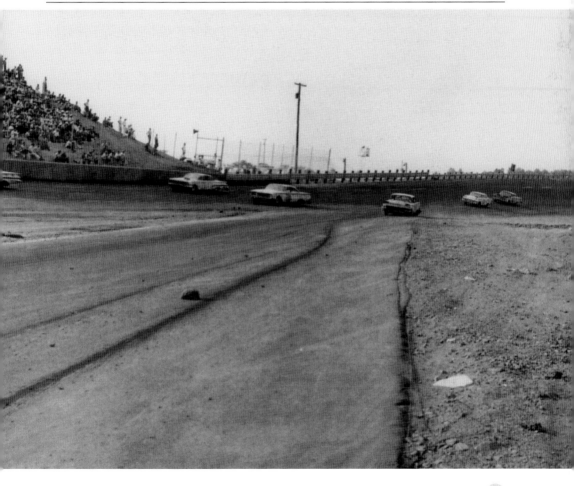

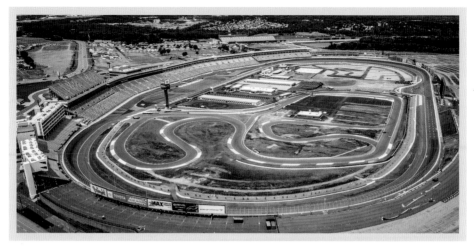

The Charlotte Motor Speedway has changed drastically since it was first built in 1960. In 2018, the track was updated from the traditional 1.5-mile oval to include a 2.28-mile, 17-turn ROVAL road course, and hosted the first road course race in the history of the NASCAR Cup Series. The speedway is considered one of the most innovative and unique tracks and is called America's Home for Racing for a reason.

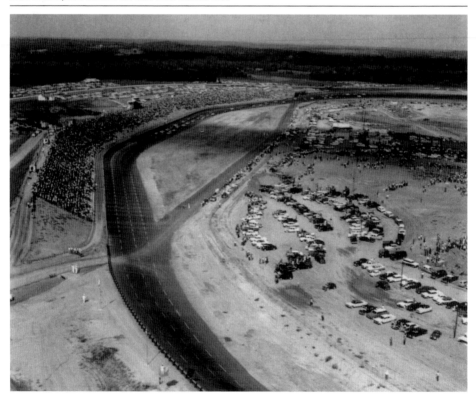

CHAPTER

3

A CENTER
FOR LEARNING
Educational Institutions

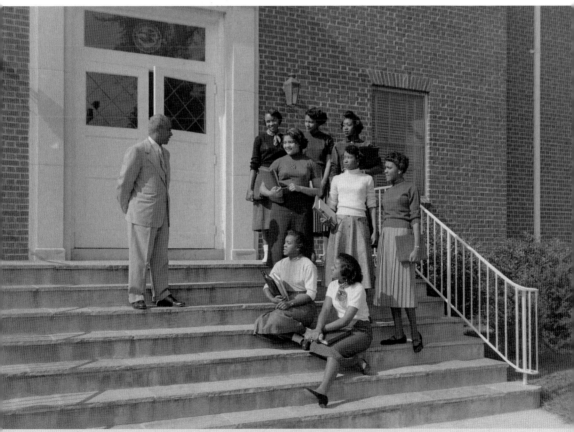

Female students at Barber Scotia College sit on the steps of the administration building, chatting with who is believed to be Dr. Leland S. Cozart, the first African American president of the school. Dr. Cozart served as the school's president for 32 years, from 1932 to 1964. Under his leadership, the school began a bachelor's degree program, became a four-year college, and transitioned to a coed institution.

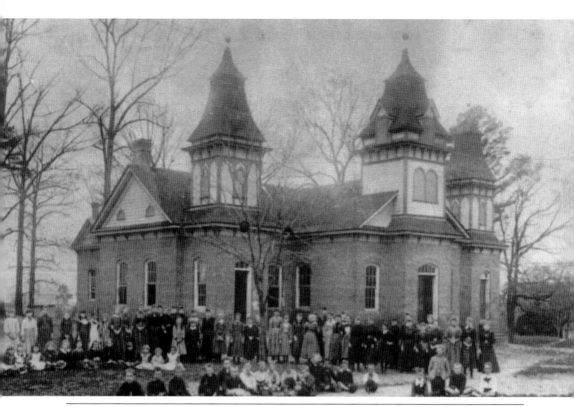

The Concord Female Academy began as a private school on Spring Street in the 1870s. On May 2, 1891, the Concord City School system was created. This building was purchased in the late 1880s and became Central School, a public institution for Concord children. It was demolished around the turn of the 20th century to make way for a larger building. (Present, Ashley Sedlak-Propst.)

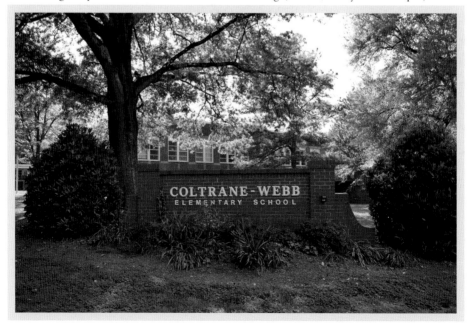

A CENTER FOR LEARNING

After Central School was demolished, this structure took its place. Central Grade School, sometimes referred to as Concord Graded School, sat at the corner of Spring Street and Grove Avenue, and was destroyed by fire on March 3, 1946. Today, Coltrane-Webb Elementary, which began as Coltrane School on September 3, 1947, is at this location. (Present, Ashley Sedlak-Propst.)

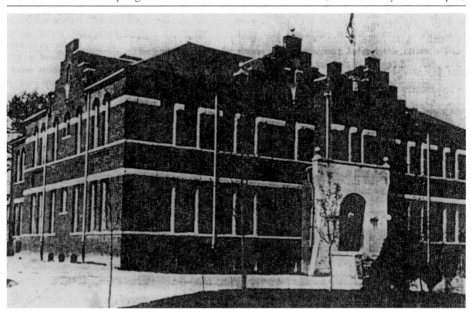

Clara Harris School began as Concord's first high school in 1893. Classes were held in the "Old Lutheran Church" building on East Corban Street, the original location of St. James Lutheran Church. The building pictured here was built in 1915 and served as Concord High School until 1924, when a larger school was built on the north side of downtown. The former high school became Clara Harris Elementary and shaped the minds of young Concord students for decades to come. Today, only the steps leading up to the school yard from Corban Street remain. (Present, Ashley Sedlak-Propst.)

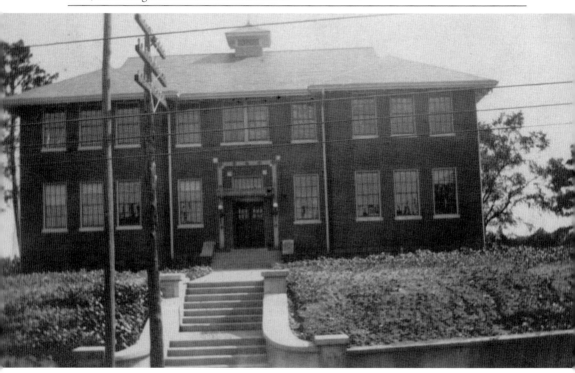

The second Concord High School building constructed in 1924 off North Spring Street partially burned in 1937. This structure replaced it and served as the high school until a new, larger school was built in 1967. After that, this building was used as a junior high and, later, a middle school. Today, it is the Glenn Center's Opportunity School and serves as a middle school and high school in the Cabarrus County school system. (Present, Ashley Sedlak-Propst.)

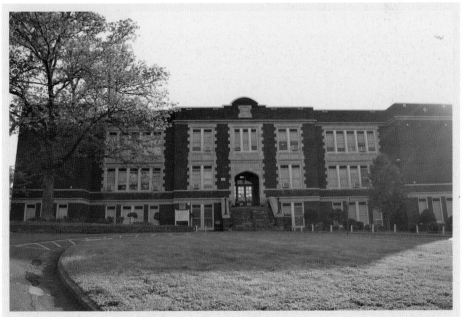

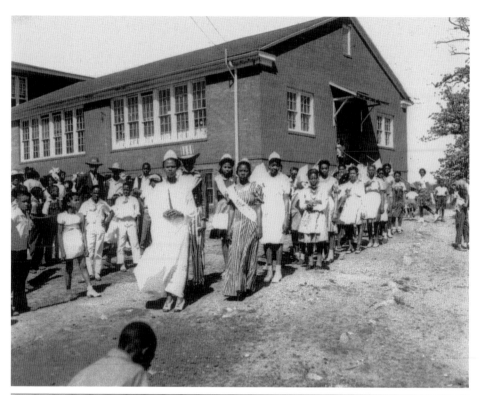

In 1891, when Concord started its public education system, a second graded school was planned and opened for African American children. The Concord Colored School stood at the corner of Chestnut Street and Tournament Drive, the current location of Grace Lutheran Church. Rev. Frank Thomas Logan, a former slave and Presbyterian minister, became the head administrator. In 1924, the school's name was changed to Logan School, and the final building was erected in 1932, with many additions and improvements added in the following years. Logan School was closed in 1967–1968 when Concord/Cabarrus County Schools were court-ordered to integrate. Unfortunately, Logan School was closed, and by 1970, the elementary grades had been completely integrated into other schools. All that remains of Logan School today is the gymnasium, and the former school site is used as a community gathering place. (Present, Ashley Sedlak-Propst.)

A CENTER FOR LEARNING

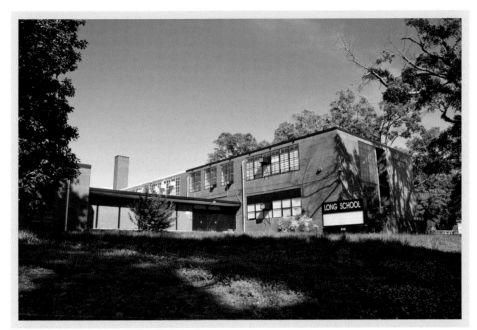

Long School began in 1901 and was first called the No. 2 School, as it was the second school opened in Concord as part of the Concord City School system. In 1929, the school's name was changed to Long School, and in 1951, the original building was demolished to make way for a larger school for students. It closed in 1975, and the building was used as a cooperative facility until 2015, when it closed permanently. (Present, Ashley Sedlak-Propst.)

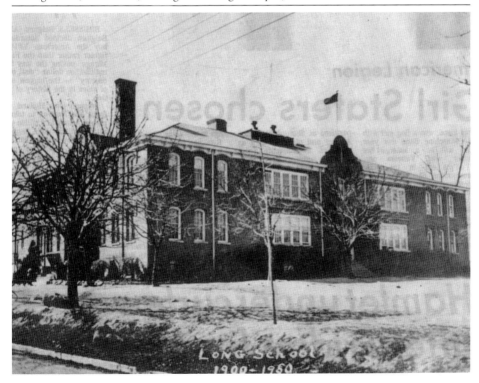

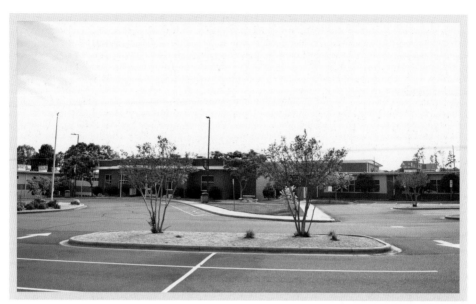

In the late 19th and early 20th centuries, African American children mostly attended small, rural schools. Like Logan School, Shankletown School had its beginnings as a one-room schoolhouse that served the Shankletown area of Concord as early as 1913. In the mid-1940s, other rural schools began to merge with Shankletown School. As black students from throughout the county began to come to the school, the need for a larger building grew. Integration closed the doors of Shankletown, as it did with so many other black schools. Today, the former Shankletown School building is part of the Concord branch of the Rowan Cabarrus Community College and houses administrative offices. (Present, Ashley Sedlak-Propst.)

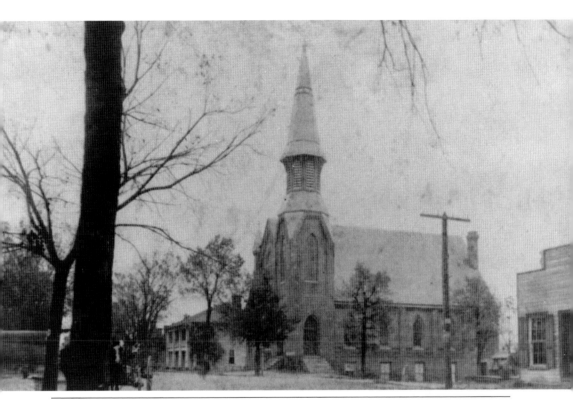

St. James Lutheran Church began in 1843 when a group of parishioners from Coldwater Lutheran Church wanted a church in the growing town of Concord. The original church was founded in the same location on Corban Street where the first Concord High School began several decades later. In 1880, a new property was purchased at the corner of Union Street and Corban Avenue, and the church pictured in the past image was built. In 1927, the current sanctuary was built to accommodate the growing congregation. In 2019, St. James Lutheran celebrated its 175th year as a congregation. (Past, courtesy of the Lawson Bonds Studio Collection, Michael A. Anderson Photography; present, Ashley Sedlak-Propst.)

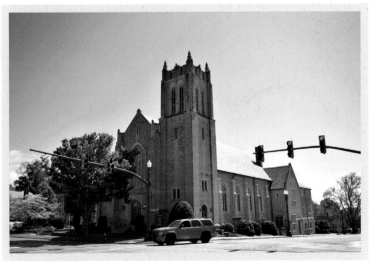

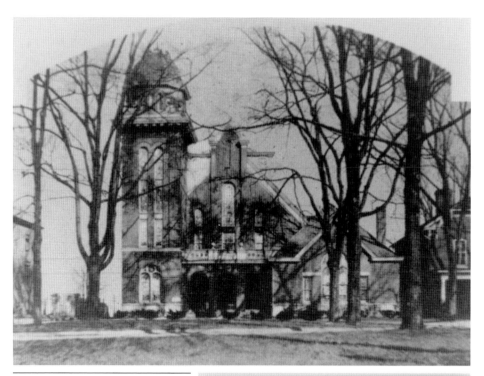

Central United Methodist Church began as the Concord Methodist Episcopal Church in a simple one-room church house in 1839 at the corner of present-day Church Street and Cabarrus Avenue. In the 1860s, the congregation moved into a second location on Union Street, and in 1902, the sanctuary pictured above was constructed. The current sanctuary, built in 1974, sits in the same location as the second and third church buildings.

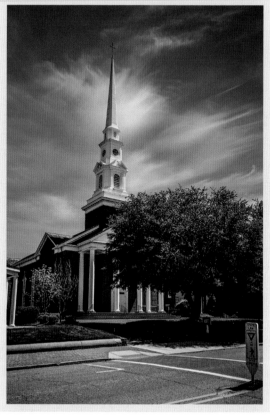

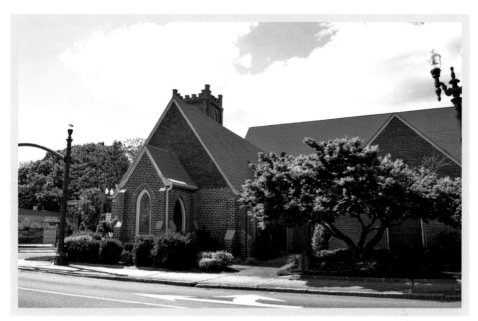

All Saints' Episcopal Church began in Concord in the 1870s, and in 1891, the property at the corner of Cabarrus Avenue and Spring Street was purchased for $300. The congregation met in the above building until June 30, 1972. In 1969, All Saints' and St. James Episcopal Church in Kannapolis merged, and a new church was built between the two towns to accommodate parishioners. The former All Saints' building downtown is now home to Impact Church International. (Past, courtesy of the Lawson Bonds Studio Collection, Michael A. Anderson Photography; present, Ashley Sedlak-Propst.)

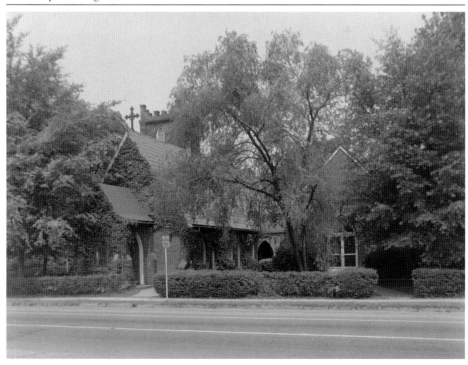

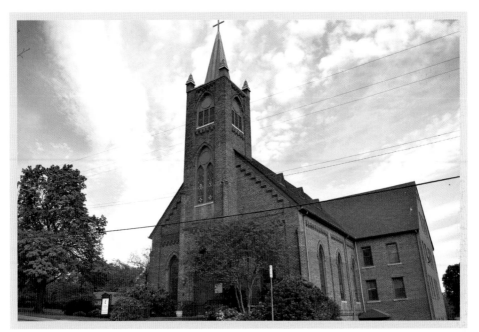

Forest Hill Methodist Church began in 1882 and was founded by J.M. Odell as a Sunday school for mill workers at Odell Manufacturing. The first sanctuary, pictured here, was built around 1889 and is still used as part of the church's campus today. The congregation now meets in the larger sanctuary that was built on North Union Street in 1986. (Present, Ashley Sedlak-Propst.)

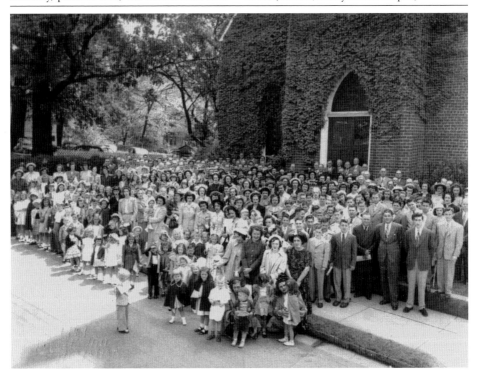

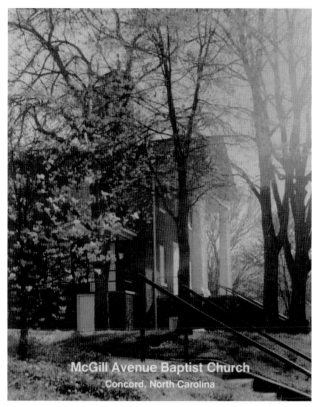

McGill Avenue Baptist Church
began as the Second Baptist
Church in 1902. By 1936, a
new brick building, pictured
here, was constructed for the
congregation. In 1990, the
church purchased property near
the Afton Village area of Concord
and constructed a new church.
The 1936 church is now used as
a health clinic.

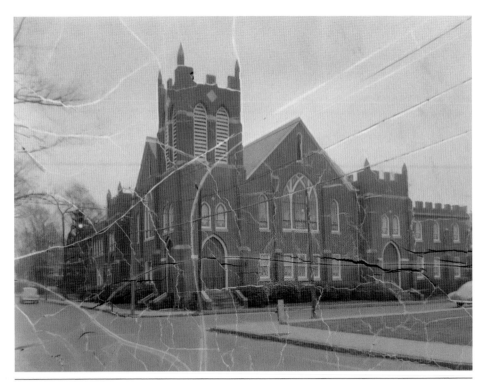

First Baptist Church of Concord first met in the 1876 Cabarrus County courthouse, and in 1889, its first sanctuary was built at the corner of Grove Avenue and Spring Street, across from the present-day Coltrane-Webb Elementary School. The second church building, pictured here, was built between 1922 and 1924 and is indicative of the Gothic Revival style that was popular at the time.

First Baptist Church moved to a new location in the late 20th century, and the Gothic church building is now the Old Courthouse Theatre, which produces plays inside the former sanctuary. (Past, courtesy of the Lawson Bonds Studio Collection, Michael A. Anderson Photography; present, Ashley Sedlak-Propst.)

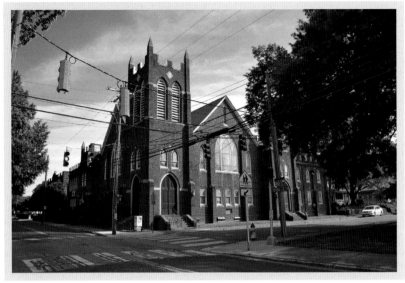

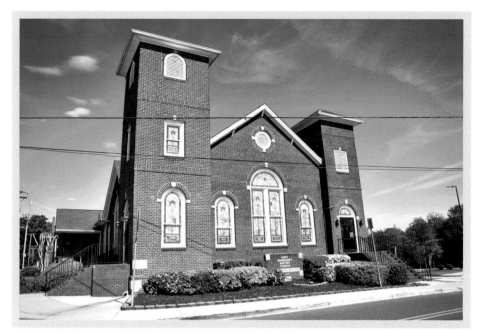

Concord's other First Baptist Church is the oldest black Baptist congregation in town. Founded around 1901, the current church building, constructed in 1925, is the second location for the congregation. The silver domes on the towers were added in 1945 and removed sometime after, having contained asbestos. (Past, courtesy of the Lawson Bonds Studio Collection, Michael A. Anderson Photography; present, Ashley Sedlak-Propst.)

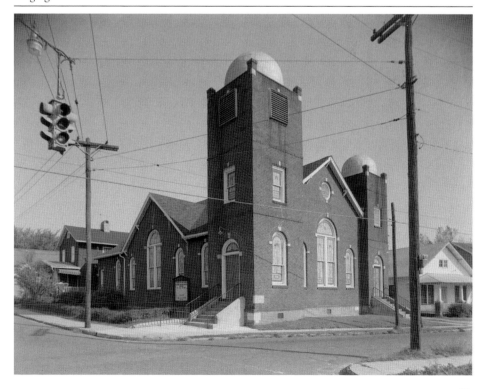

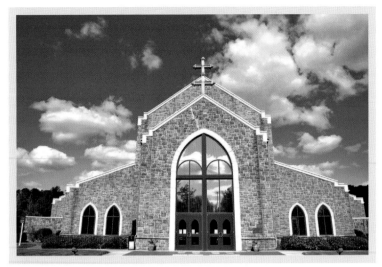

St. James Catholic Church was dedicated on August 1, 1869, by Rt. Rev. James Gibbons. The first sanctuary was built on top of a hill on Gold Hill Road, a few miles out of town. In 1954, the first church building, pictured in the past image, was destroyed by fire, and the congregation decided to build a church in Concord. The second building is now used by Forest Hill Methodist Church. St. James built a larger sanctuary, seen above, on the other side of Concord in 1986. (Past, courtesy of the Lawson Bonds Studio Collection, Michael A. Anderson Photography; present, Ashley Sedlak-Propst.)

WHERE HOME IS INDEED A HOME

STREETSCAPES AND HISTORIC HOMES

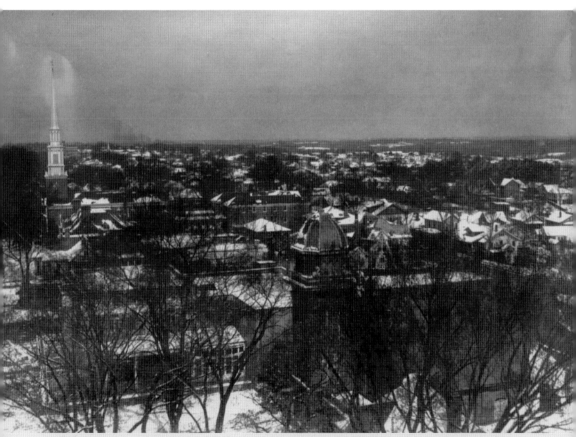

This view, most likely from the top of the Hotel Concord, shows Church Street looking north under a blanket of snow. The dome of Central United Methodist Church is in the center foreground, and the white steeple of the 1927 First Presbyterian Church is on the left. A water tower, likely used for Odell-Locke Mills, is visible in the distance at left center.

85

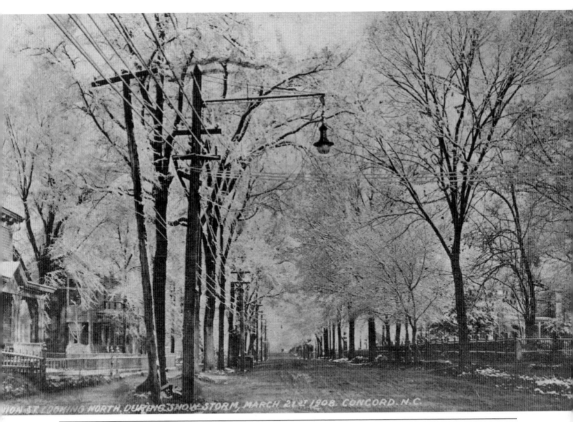

ION ST. LOOKING NORTH, DURING SNOW STORM, MARCH 21st 1908. CONCORD. N.C.

Taken after a snowstorm on March 21, 1908, this photograph looks north on Union Street from Holly Lane (modern-day Killarney Avenue). Several of the homes on both sides of the street are no longer there today. The commercial part of North Union Street has spread into the former residential area, and the sanctuary and manse for First Presbyterian Church are now on the right side of the street. (Present, Ashley Sedlak-Propst.)

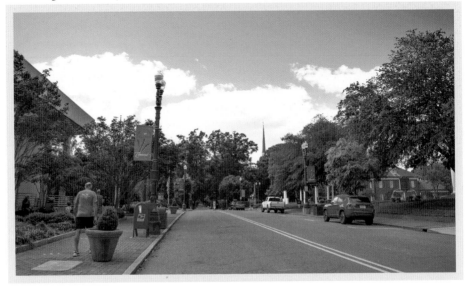

Where Home is Indeed a Home

This photograph of North Union Street, taken sometime in the last decade of the 19th century, shows the "dummy" line for the steam-powered engine that traveled up and down Union Avenue and Depot Street, bringing passengers from the Concord Depot into downtown. Today, the rail line is a distant memory, but the tree-lined street still brings visitors from near and far. (Present, Ashley Sedlak-Propst.)

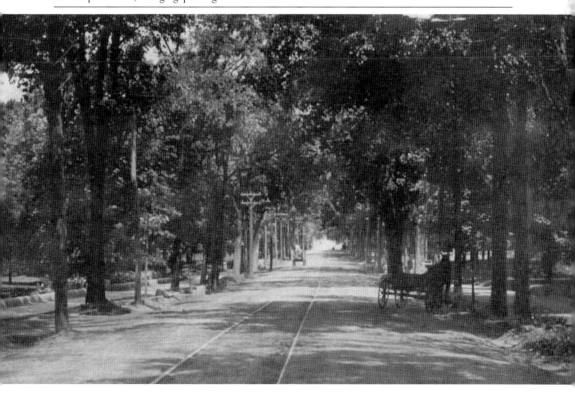

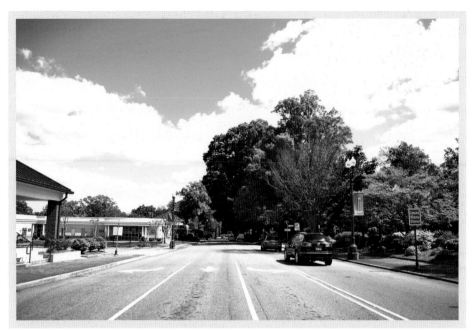

This c. 1905 photograph looking toward the South Union residential area was taken from near the intersection of Corbin Street. Union Street had been graded but was still unpaved. The home to the right is the Foard House, which was torn down at the end of the decade to build the 1911 post office. The brick structure on the left is now Rotary Square. (Present, Ashley Sedlak-Propst.)

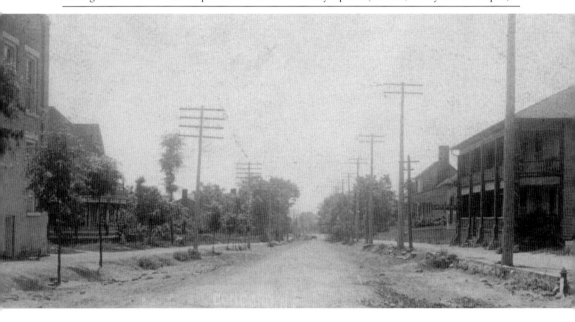

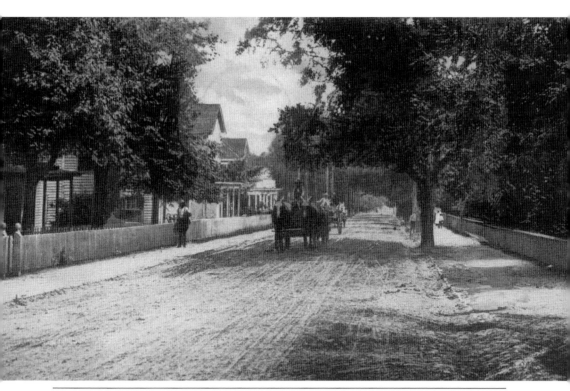

This is an early 1900s photograph of West Depot Street. Picket fences lined the streets then, and the dirt road shows the wear of wagon wheels. Dirt sidewalks are on both sides of the street. The fence on the right was in front of the Beatty House, which was built in the mid-1870s. Today, the Beatty House (56 Cabarrus Avenue West) and 67 Cabarrus Avenue West still overlook a paved Cabarrus Avenue. (Present, Ashley Sedlak-Propst.)

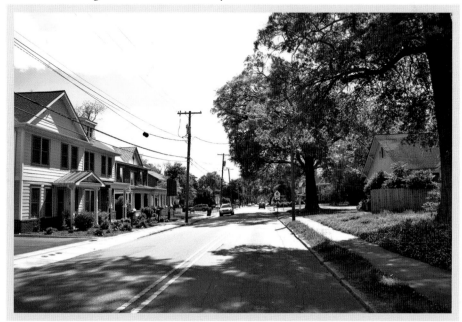

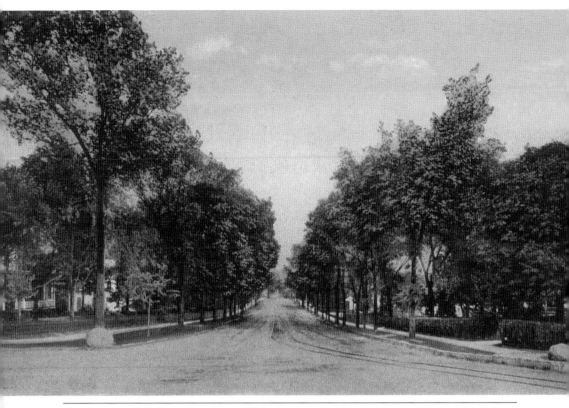

This c. 1900 view shows Union Street looking south from Buffalo Avenue. The photograph was taken right in front of Locke Mills. The John Milton Odell House, built by the founder of Odell Manufacturing Company, is on the left. The large stone sitting on the left corner can be found in the front yard of the Odell House today. (Present, Ashley Sedlak-Propst.)

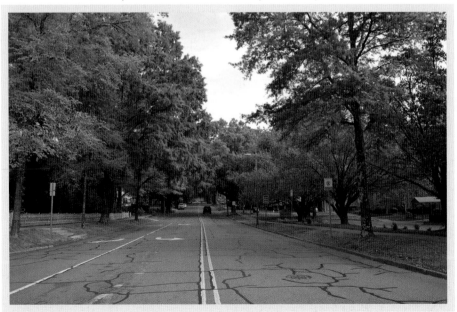

WHERE HOME IS INDEED A HOME

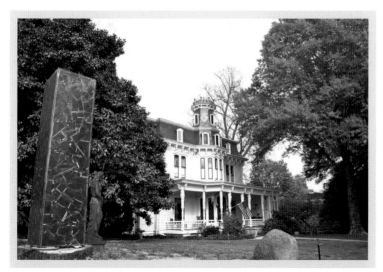

The designer of the J.M. Odell House drew inspiration from the architecture of another building being constructed in Concord around the same time. Architect George S.H. Appleget designed the Cabarrus County Courthouse, and an unknown architect copied the same blend of Italianate and Second Empire styles. The mansard roof and the central tower are similar to the roof and clock tower of the courthouse just a few blocks south. (Present, Ashley Sedlak-Propst.)

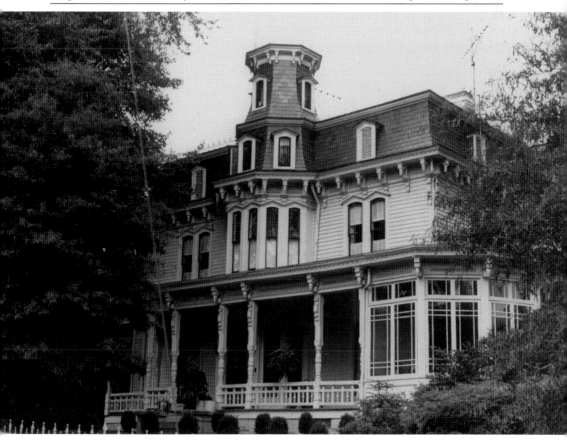

J.M. Odell's son William R. Odell built this elaborate Victorian-style home directly across the street from his father, J.M. Odell, in the early 1880s. The two Odell homes made a grand entrance to Union Street and downtown Concord. This home was sold to Forest Hill Methodist Church after W.R. Odell's death and was demolished to make way for the church's expansion in the 1960s. (Present, Ashley Sedlak-Propst.)

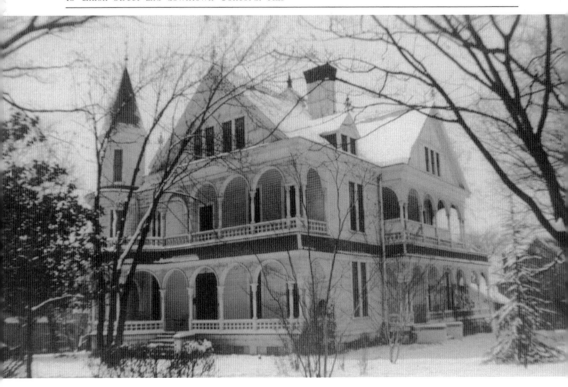

WHERE HOME IS INDEED A HOME

J.W. Cannon, the founder of Cannon Mills, built his first home on Union Street in the 1870s. It was a distinctive embodiment of the Italianate style that was so popular at the time, but it was heavily remodeled in the 1920s after Cannon sold it to Martin Boger. Today, the unique brick structure is still one of the most outstanding homes on North Union Street. (Present, Ashley Sedlak-Propst.)

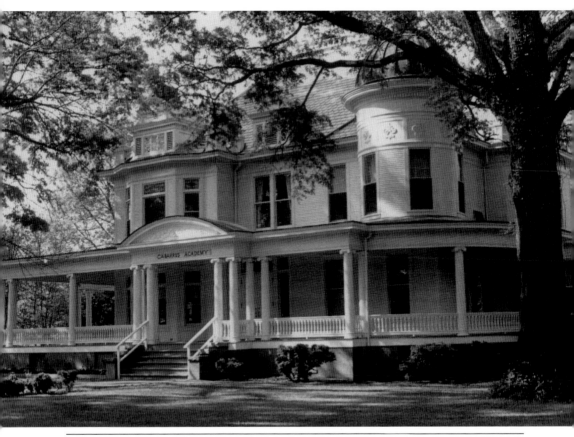

The second J.W. Cannon home was built around 1900. The Queen Anne–style home showcases a unique domed turret and is one of the most imposing residences on North Union Street. In 1969, the house was turned into the Cabarrus Academy, which operated as a school in downtown Concord until the mid-1990s, when 65 acres were purchased for a larger campus. The school was renamed the Cannon School, and is one of the most prestigious private schools in Cabarrus County. The former Cabarrus Academy was purchased in the late 2010s and restored as a private home. (Present, Ashley Sedlak-Propst.)

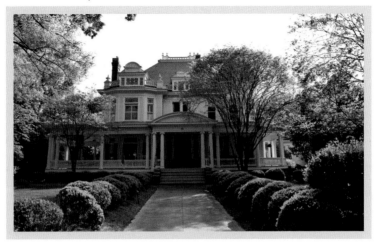

WHERE HOME IS INDEED A HOME

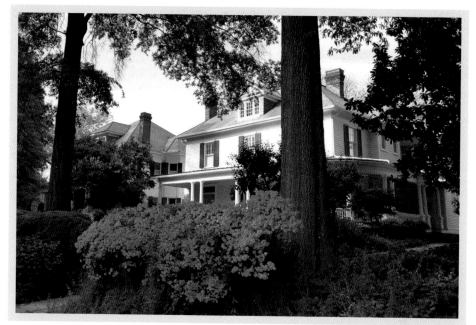

North Union Street was the main residential neighborhood for Concord's leading industrialists and businessmen. Many of the homes still standing on the street were built following the Civil War to the beginning of the 20th century. These two homes were designed and built by Charlotte architect Louis H. Asbury in the early 1910s and 1920s for J. Archibald Cannon (left) and David Franklin Cannon (right), two sons of Cannon Mills founder J.W. Cannon. Both North and South Union Streets still maintain a high degree of architectural integrity from the late 19th and early 20th centuries. (Present, Ashley Sedlak-Propst.)

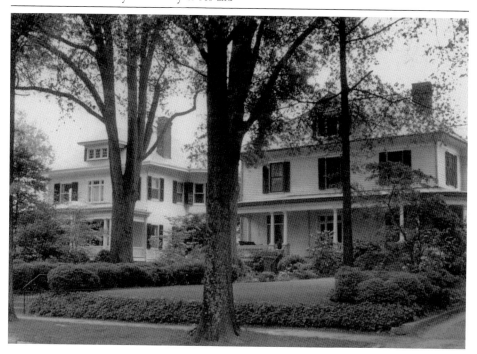

DISCOVER THOUSANDS OF LOCAL HISTORY BOOKS
FEATURING MILLIONS OF VINTAGE IMAGES

Arcadia Publishing, the leading local history publisher in the United States, is committed to making history accessible and meaningful through publishing books that celebrate and preserve the heritage of America's people and places.

Find more books like this at
www.arcadiapublishing.com

Search for your hometown history, your old stomping grounds, and even your favorite sports team.

Consistent with our mission to preserve history on a local level, this book was printed in South Carolina on American-made paper and manufactured entirely in the United States. Products carrying the accredited Forest Stewardship Council (FSC) label are printed on 100 percent FSC-certified paper.

MADE IN THE
USA